FLARE MAGAZINE PRESENTS

MADE IN CANADA

PHOTOGRAPHS BY BRYAN ADAMS

FOREWORD BY MARGARET ATWOOD

KEY PORTER BOOKS

In the March 1998 issue of *Flare* magazine, I was thrilled to publish a photograph of Linda Evangelista taken by Bryan Adams. Not only was the picture a unique record, marking a historic charitable initiative by two Canadian icons, but it was, simply, a stunning image. When he subsequently called with the idea of doing more photography featuring Canadian women, David Hamilton, *Flare*'s publisher, and I were happy to embark on this special book project as a way to commemorate the 20th anniversary of the magazine, which is in September 1999. This book is meant to celebrate and to give back to Canadian women, and since breast cancer will strike one in nine of us and affect all around, all royalties from the sale of this book will be donated to the Canadian Breast Cancer Foundation.

None of this would be possible without those at Kodak Canada, who gave their support by sponsoring this book. I would like to thank them. And this letter would not be complete without a special thank you to all the members of *Flare*'s editorial team for their contributions, large and small.

To each and every woman who was photographed: for giving so generously of yourselves, thank you.

But, most of all, I would like to thank Bryan Adams for his passion, his drive, his commitment and his wonderful ability to capture, with honesty and artistry, the beautiful spirit of our women. **Suzanne Boyd Editor-in-Chief**

A few words from a company known for pictures ... For Kodak Canada, 1999 is a year of celebration, as we mark our 100th year as a Canadian company. To most Canadians, we are well known for the role we played in helping them, their parents and grandparents preserve their life memories by making photography accessible and fun.

Fewer people know the part we play in Canadian health care. Kodak has been making important contributions to the science of diagnostic imaging throughout the last century. Mammography has been a key area of this endeavour. Today, Kodak remains at the forefront of mammography with state-of-the-art products and solutions that continue to set industry standards.

While routine mammography screening saves lives through early detection, work must aggressively continue to eliminate the need for it. Research must lead the way to the prevention, and eventual elimination, of breast cancer.

It is toward this end that we place Kodak Canada's support behind *Made in Canada*, as part of this year's incremental corporate donations effort and as part of our celebrations in this very special centennial year. **Ed Jurus President and CEO, Kodak Canada Inc.**

In some ways, this book project started when *Flare* magazine published my photograph of model Linda Evangelista in 1998, promoting a concert she and I were co-sponsoring to raise money for a breast cancer screening clinic in St. Catharines, Ontario. Previously, I had recorded some music for a CD and performed at another concert in Los Angeles, both for breast cancer research, so the idea of continuing to raise awareness was at the forefront of my mind. I approached *Flare* with the idea of continuing to promote awareness, hence this book. Shortly afterward, I discovered that one of my friends, Donna, had become afflicted with the disease.

Donna graces the front cover and is the closing photograph inside. She was in the final stages of extreme chemotherapy and radiation treatments when she agreed to be photographed. She was very tired and emotional during the shoot; we spoke about her two children and her husband—she was worried about their well-being without her. At one point, she asked me to touch her shoulder and to feel the cancerous tumours underneath her skin. She showed me the tattoo marks on her chest and back left by the needles of the cancer treatments. She was hopeful that what she had been through would prolong her life and that she could get back to being herself again and go to her children's dance that night. As she walked out, she requested that I list her only as "Donna" and leave her family name out. I have respected her wishes and felt many times throughout the year that it took to do this book that she was the inspiration, helping to guide me along when I wasn't going to get the shot I wanted, and encouraging me to keep at it when people were understandably averse to having their picture taken. I think her portrait looks hopeful, but she was my age when she passed away—38.

I am extremely grateful to all those who gave both time and money to help make each photo happen and especially to the women photographed here who were Made in Canada. **Bryan Adams**

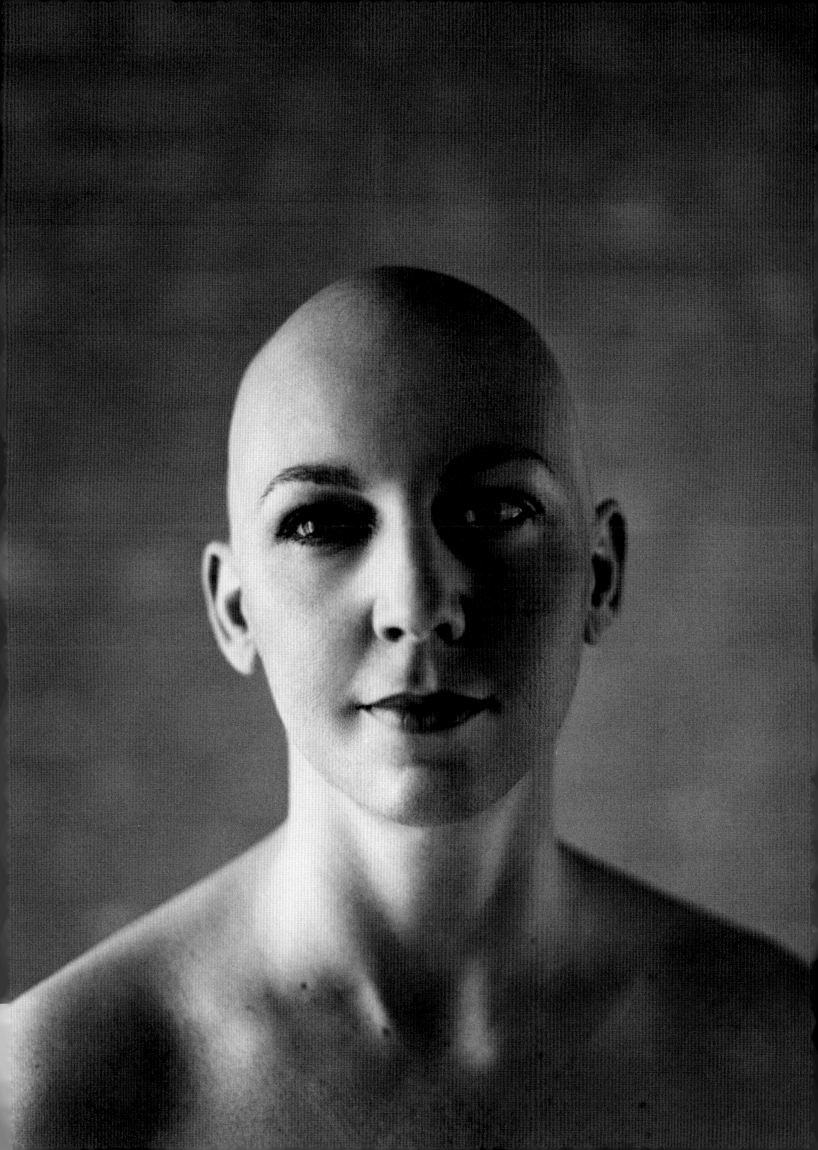

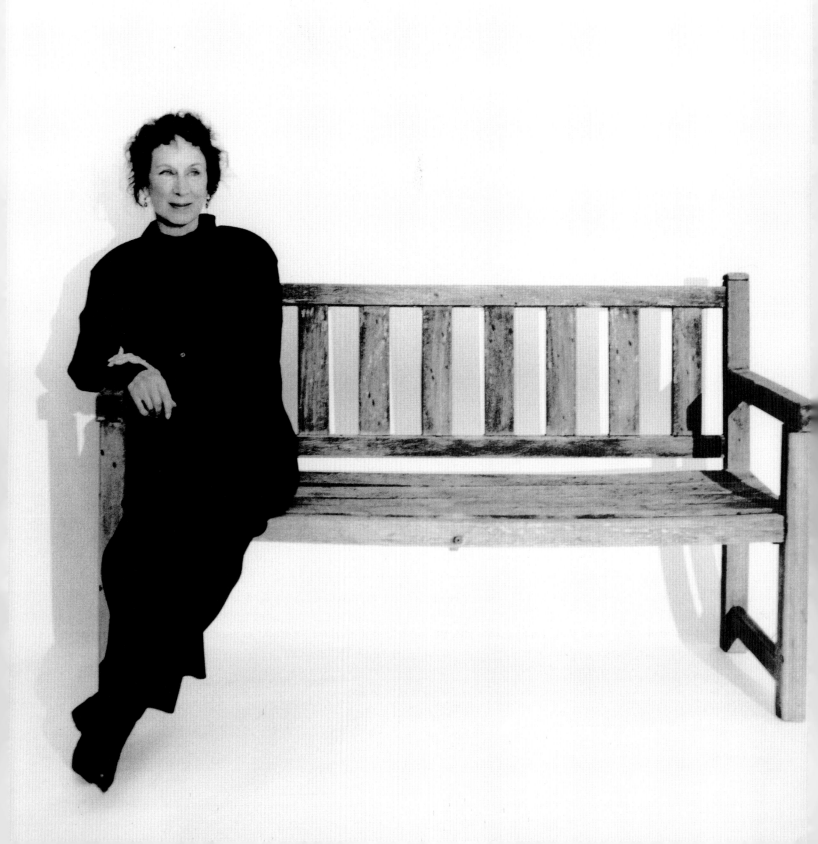

On the 22nd of March, 1999, I was frantically running around in the London Underground, having misplaced myself on the Jubilee Line. I was late for an appointment with Bryan, who wanted to take my photograph for inclusion in a book in aid of breast-cancer research. So mysterious was his abode that no cab driver would take me there. Once I emerged from the Underground, I had to call Bryan from a phone booth and then hang around flagging down cars that looked like the one he'd described but that didn't have him in them. Policemen began giving me suspicious looks. I'm glad they didn't ask: the story was improbable. Finally, the right combination of car and star arrived, and we rushed off to take the picture. Bryan and his assistants were kindness itself, but by this time it was drizzling. The light was better outside, however, and we know how photographers are about light. As I sat on a windswept London roof, on a park bench, on a sheet of white paper, with a film of raindrops settling down over me, I wondered, Why am I doing this?

Over the next few days, I gave it some thought. Here's why: in the '70s, a friend of mine died of breast cancer. She was in her early 30s, with two young children, and had just begun a promising career as a poet. She'd been misdiagnosed—only a cyst, nothing to worry about—and, by the time she got a second opinion, it was too late.

Then, in 1981, I published a novel called *Bodily Harm*. It begins after the central figure in it has had a partial mastectomy. The publishers told me that if I'd submitted it two or three years previously, they'd have had a difficult time publishing it—even that late in the 20th century, the subject was all but taboo.

The day after the photo shoot with Bryan, I received word that one of my oldest friends from college days had just had a mastectomy. And the day after that, I heard that a writer friend who'd had breast cancer, but who'd had a remission, was now very ill again.

It's not in my family much, I told my own doctor after a false alarm. Don't count on it, he said grimly. He'd heard that one before.

Cancer is all around us. It's in the air, you might say. Statistically, one in nine North American women will have a bout with breast cancer—over the age of 50, it's one in four. That fewer will die from it than in the past—when almost all of them did—is due to new methods of treatment and diagnosis, based on new research. Still, our women friends, members of our family, our female colleagues—all are potentially at risk. But many can be saved.

That's why Bryan was taking the photographs. That's why I was sitting in the rain. A small gesture, but something is better than nothing. **Margaret Atwood**

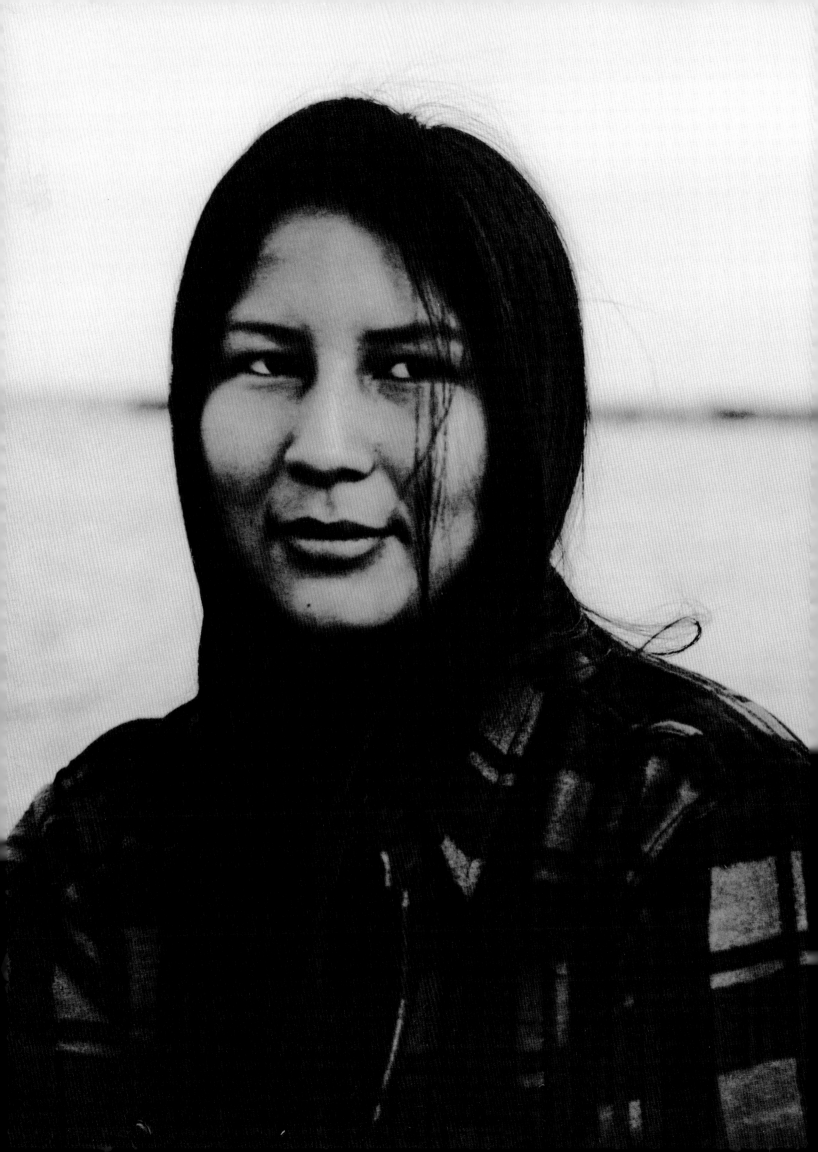

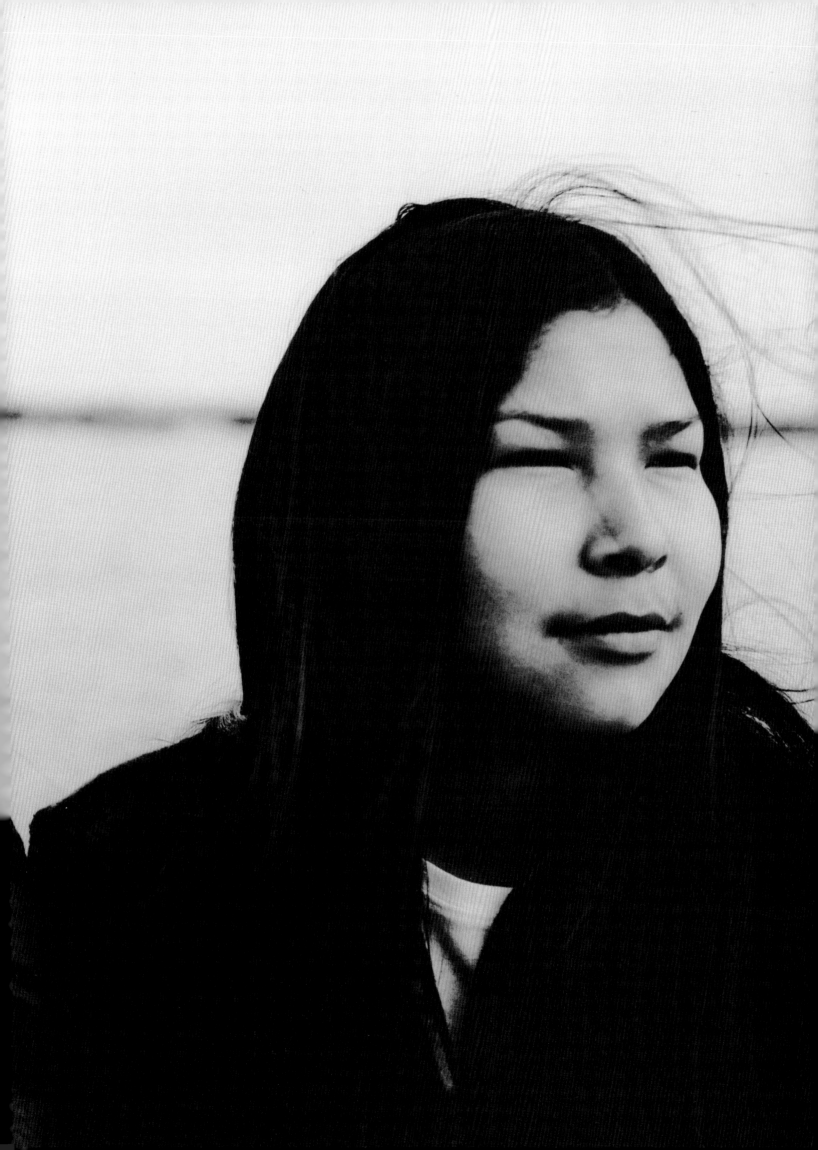

SHALOM HARLOW
model/actor

previous spread
NATALIE AND JUANITA NEGANEGIJIG
students

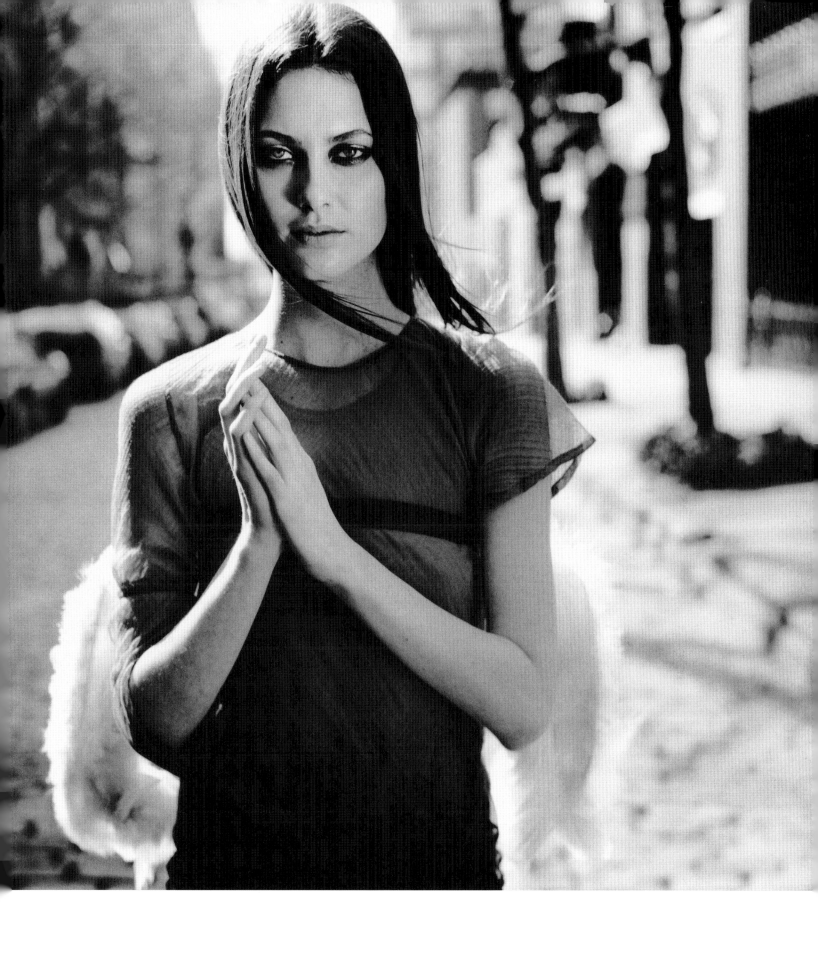

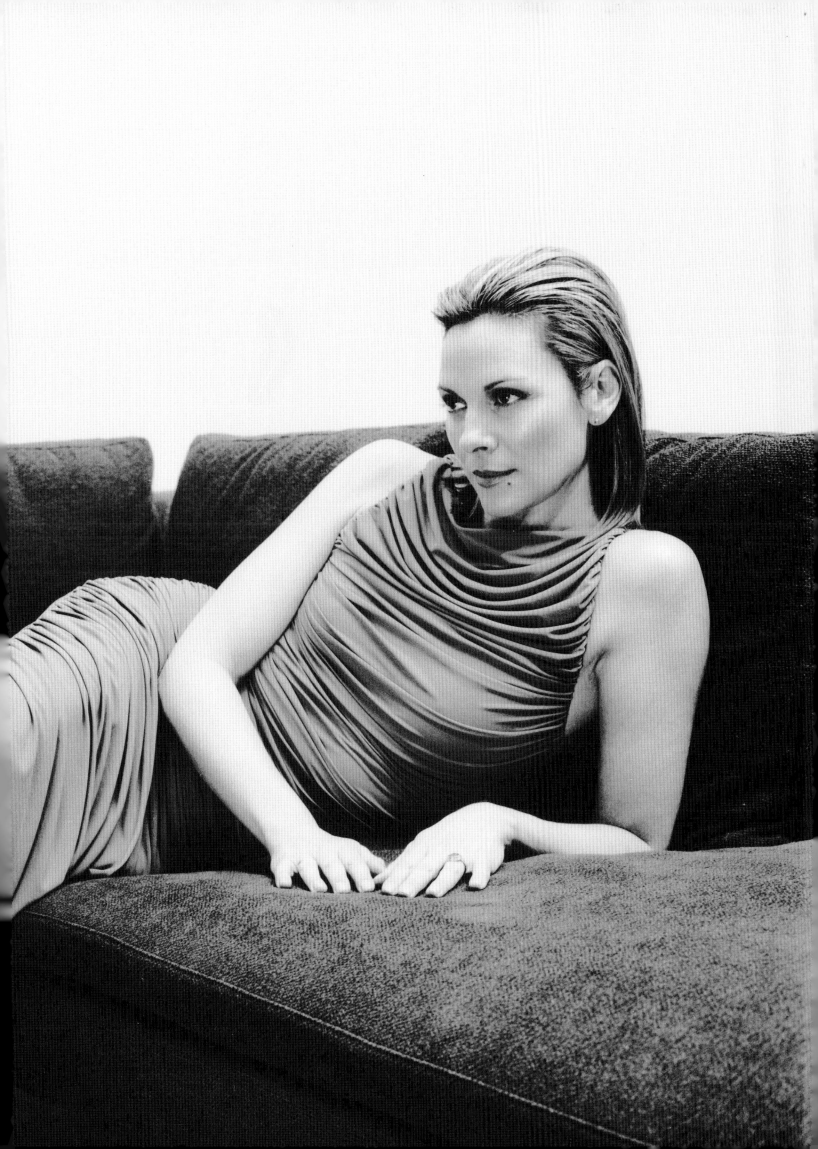

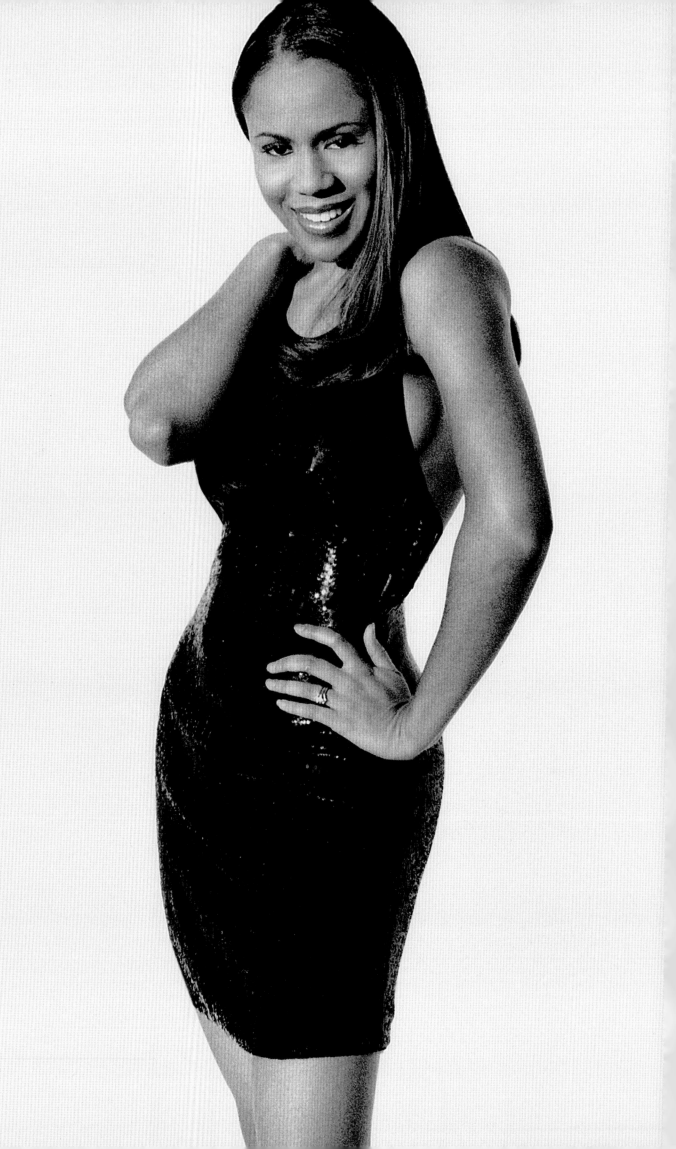

DEBORAH COX
recording artist

previous spread

KIM CATTRALL
actor/writer

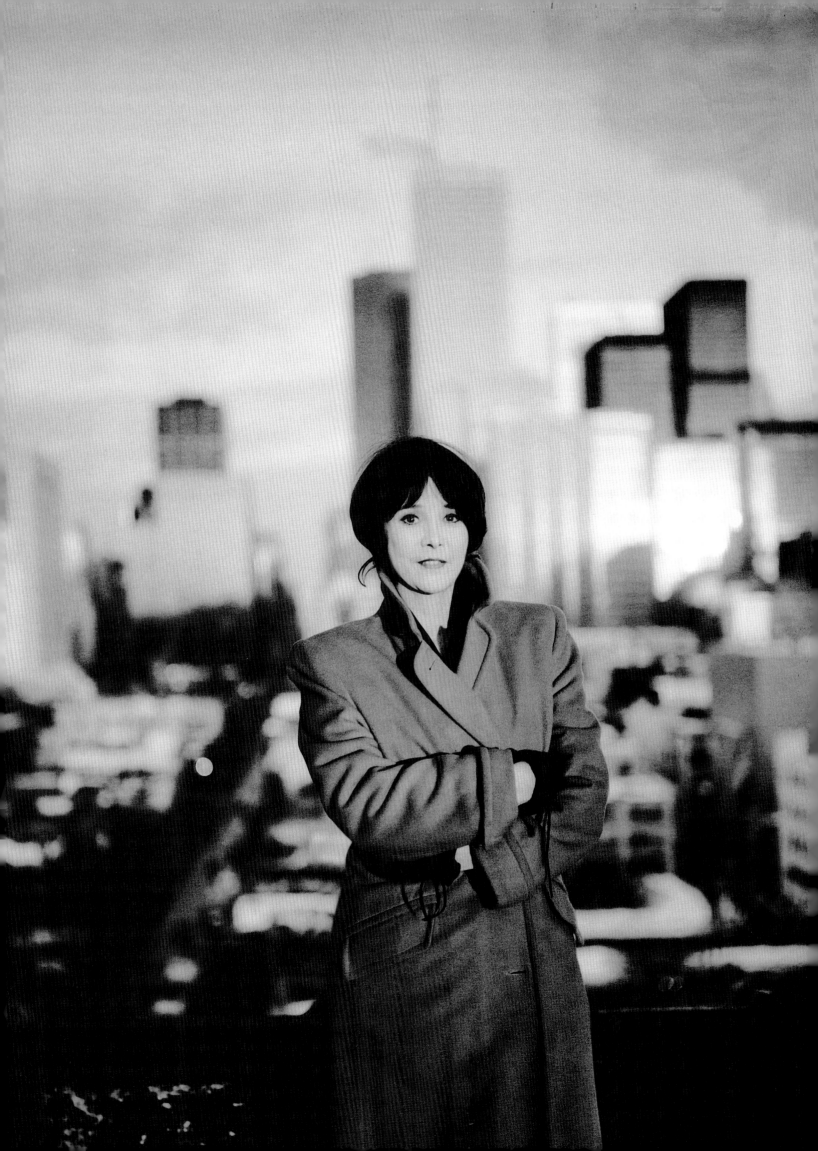

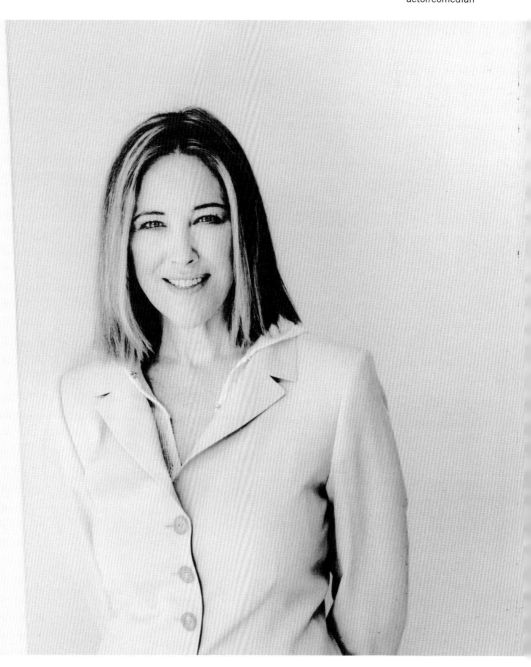

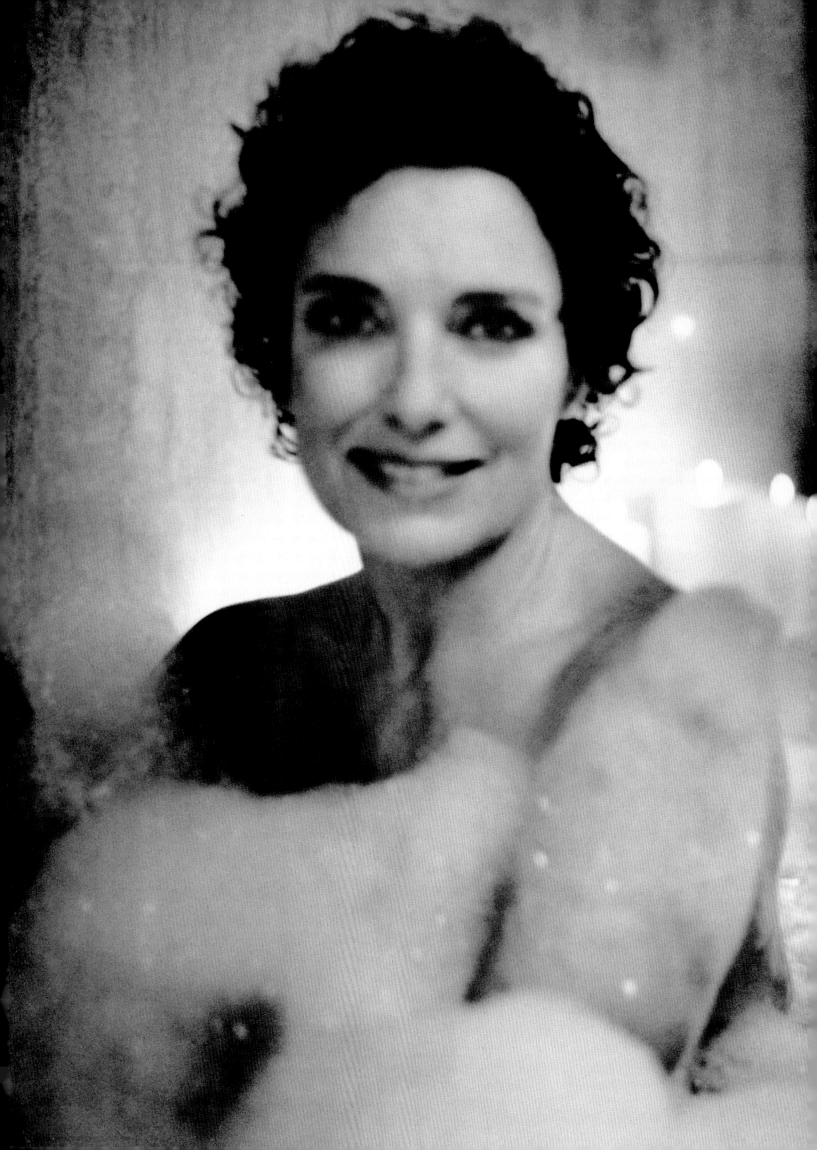

MARGARET TRUDEAU
former wife of a former prime minister

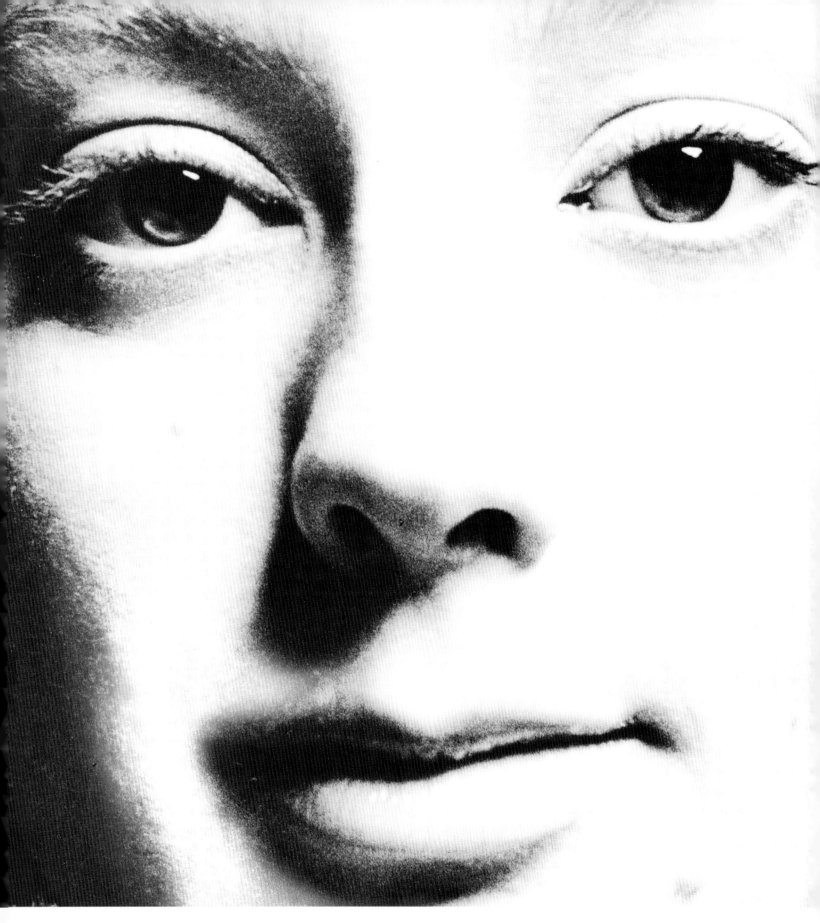

above

SARAH MCLACHLAN
singer/songwriter

right

JONI MITCHELL
singer/songwriter/artist/painter

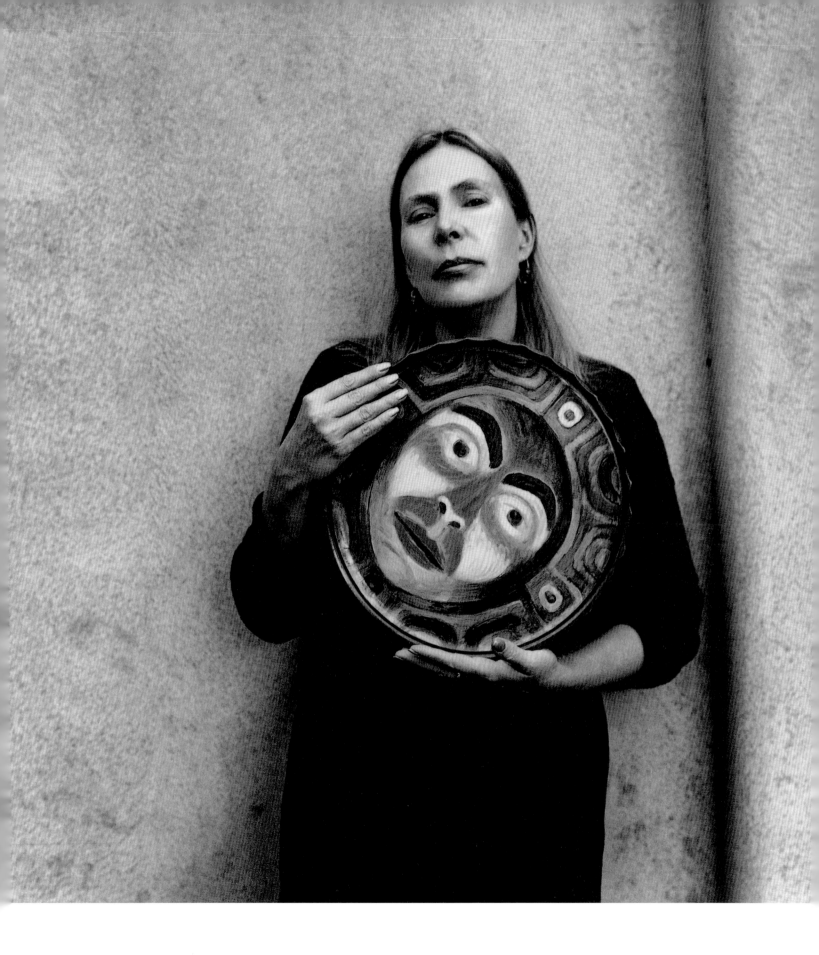

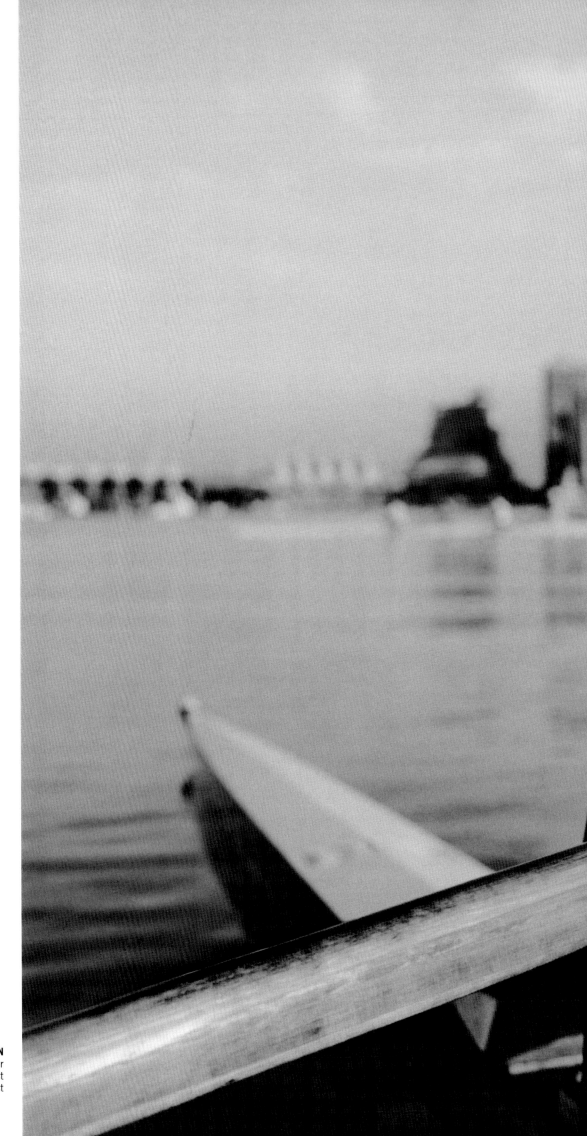

SILKEN LAUMANN
Olympic rower
silver medallist
two-time bronze medallist

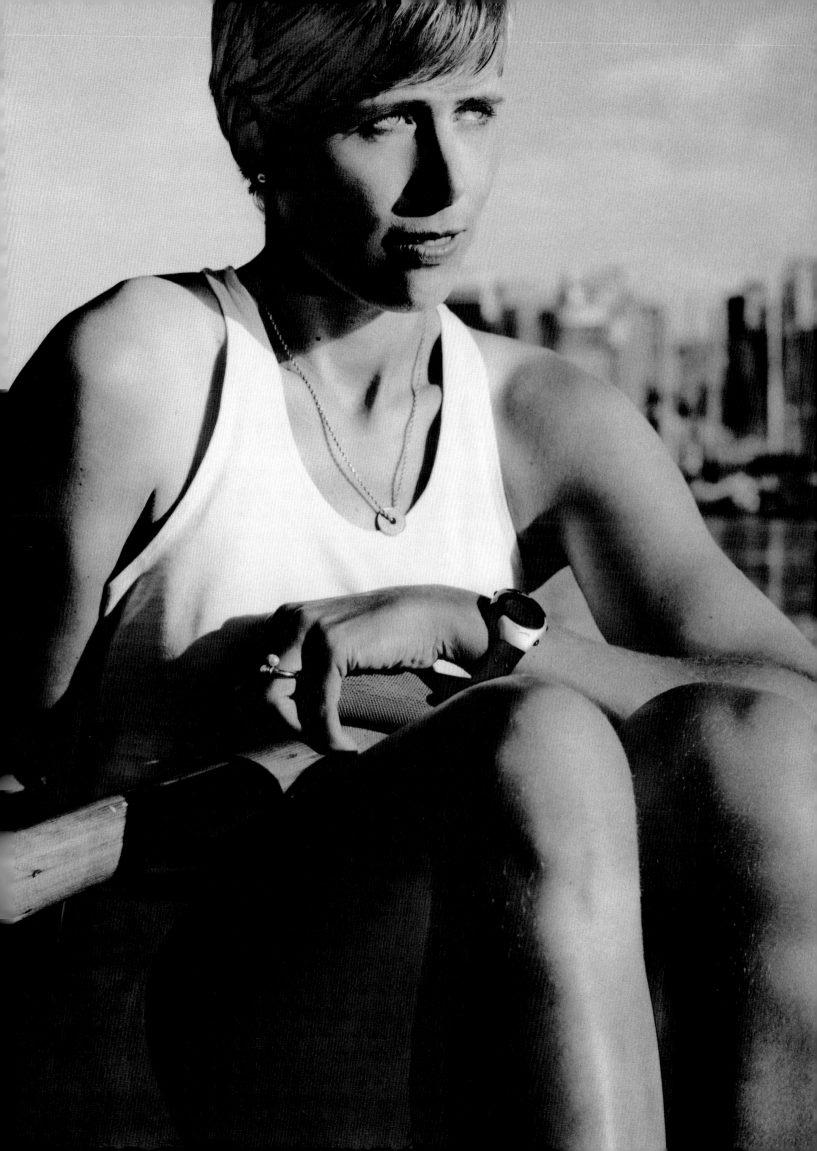

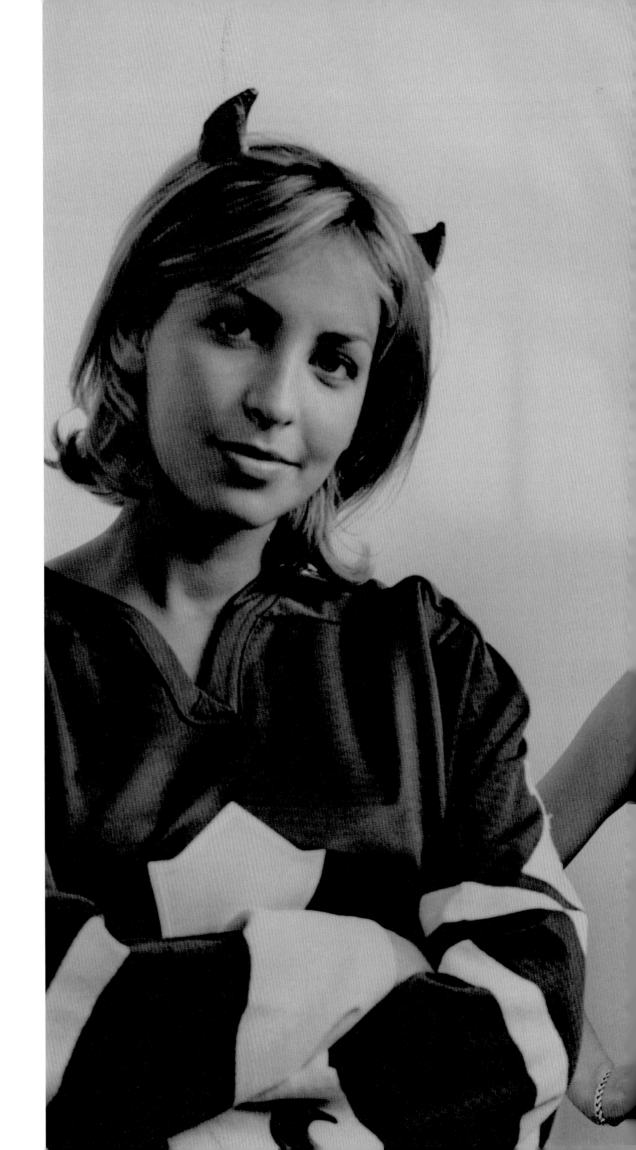

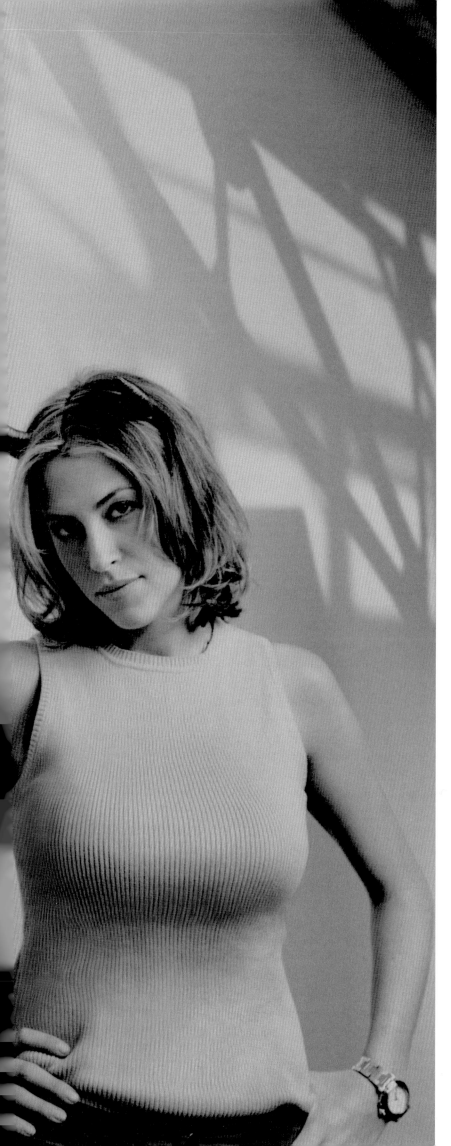

NATALIE AND NICOLE APPLETON
singers
All Saints

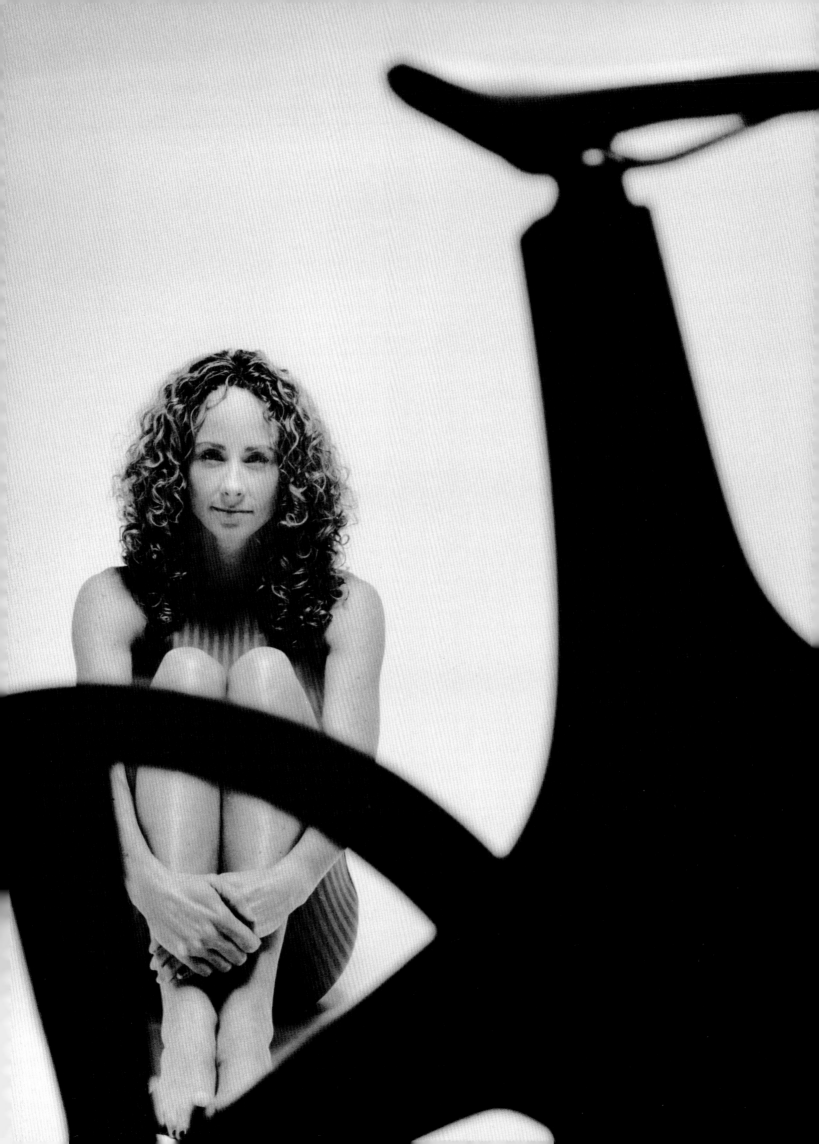

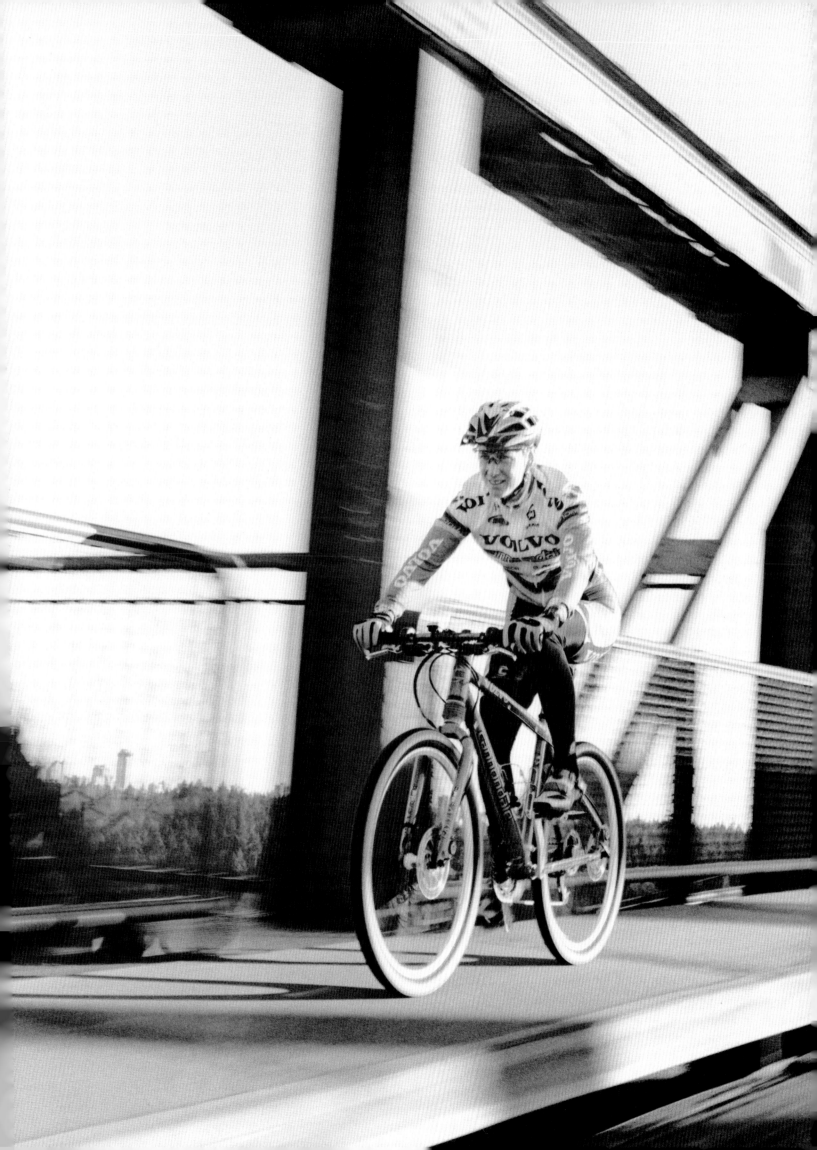

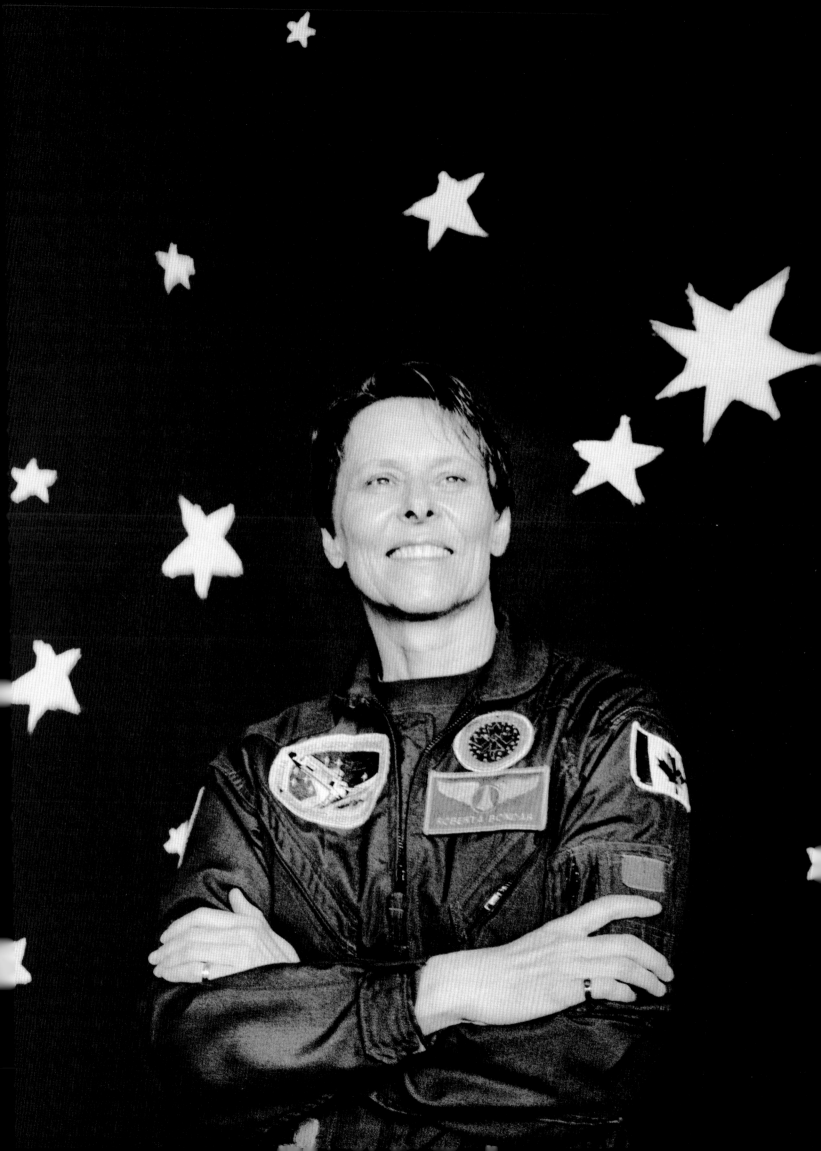

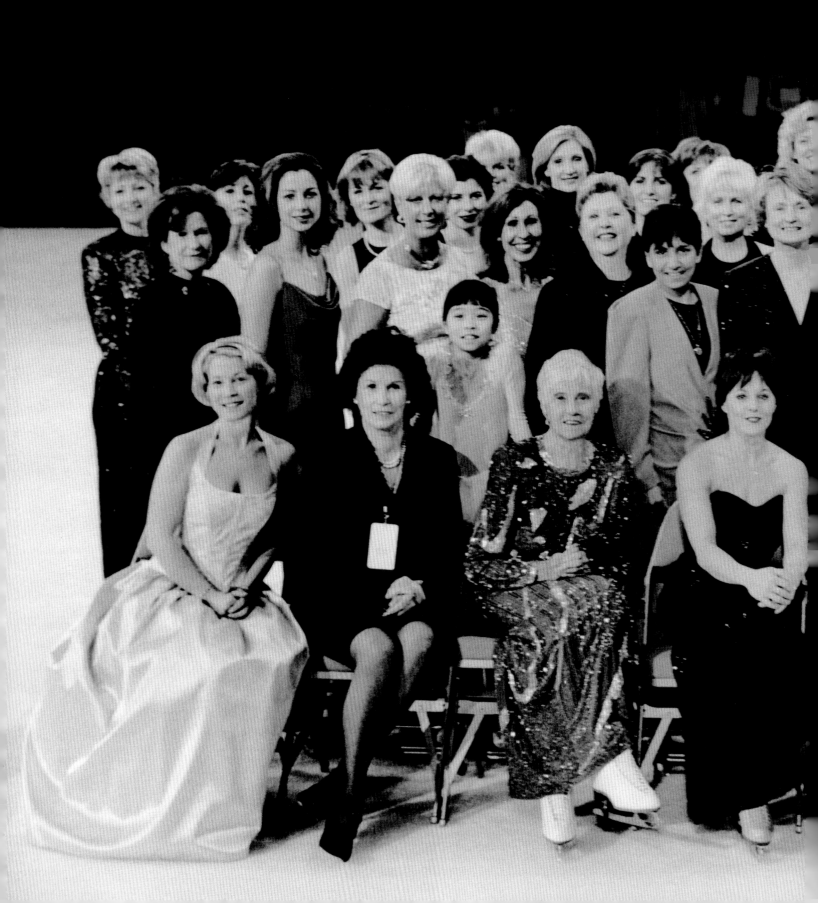

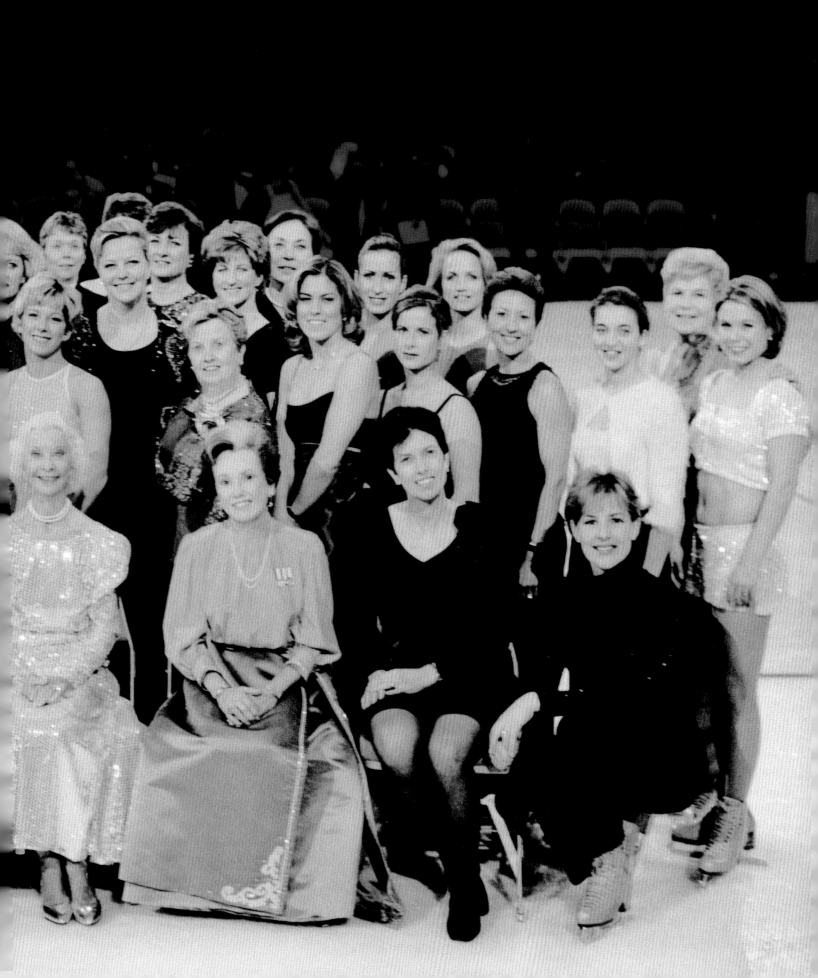

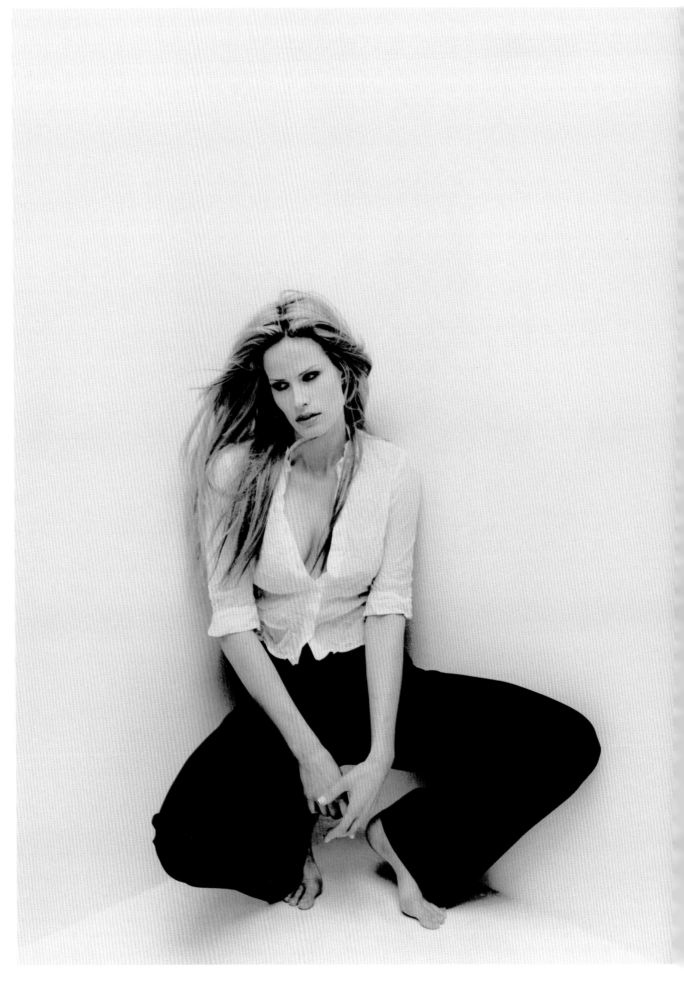

MONIKA SCHNARRE
actor/former Ford Supermodel of the Year

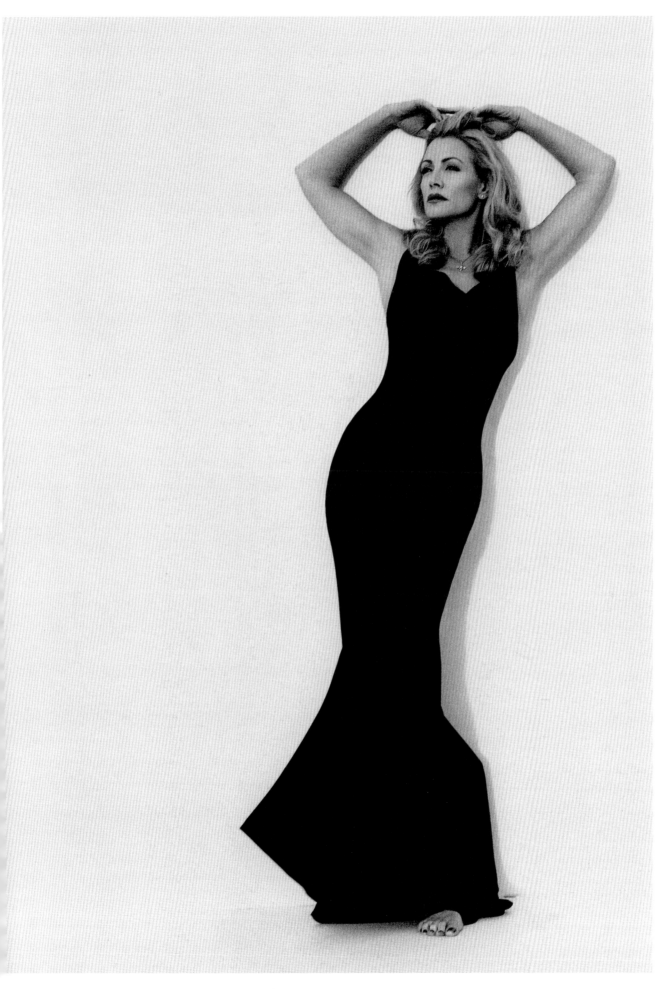

SHANNON TWEED
actor/former Playboy Playmate of the Year

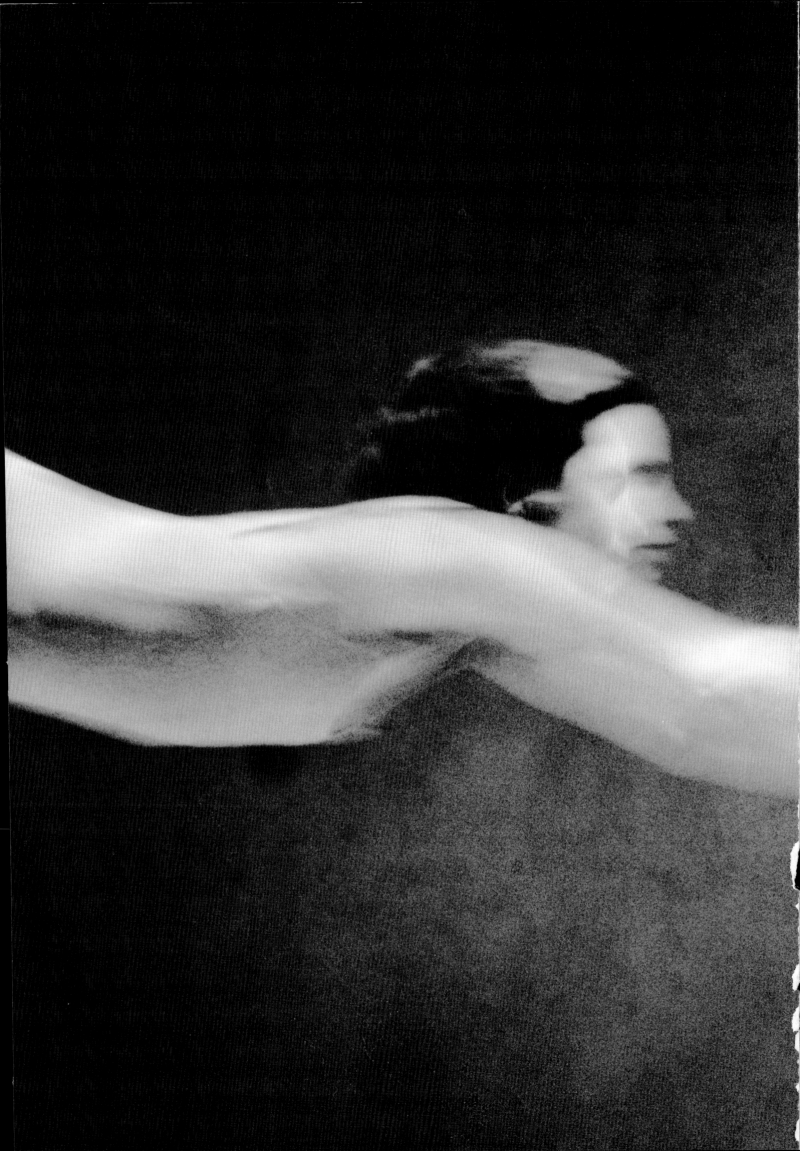

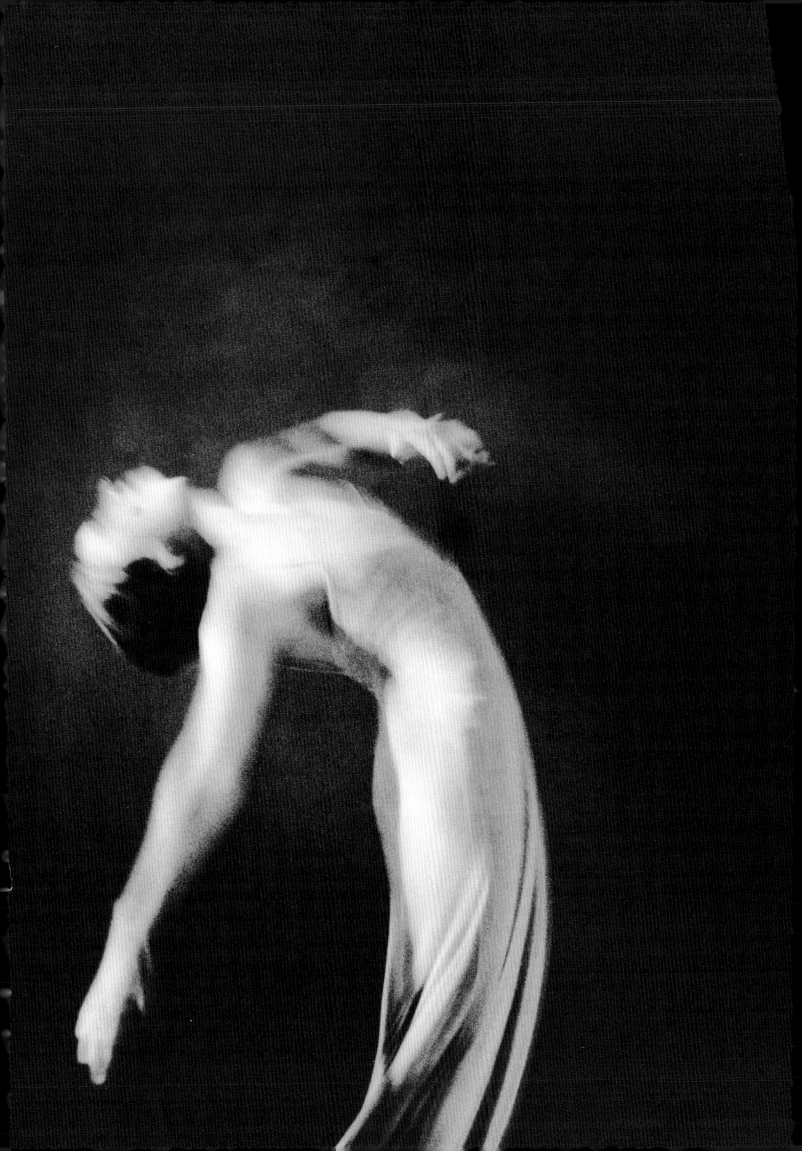

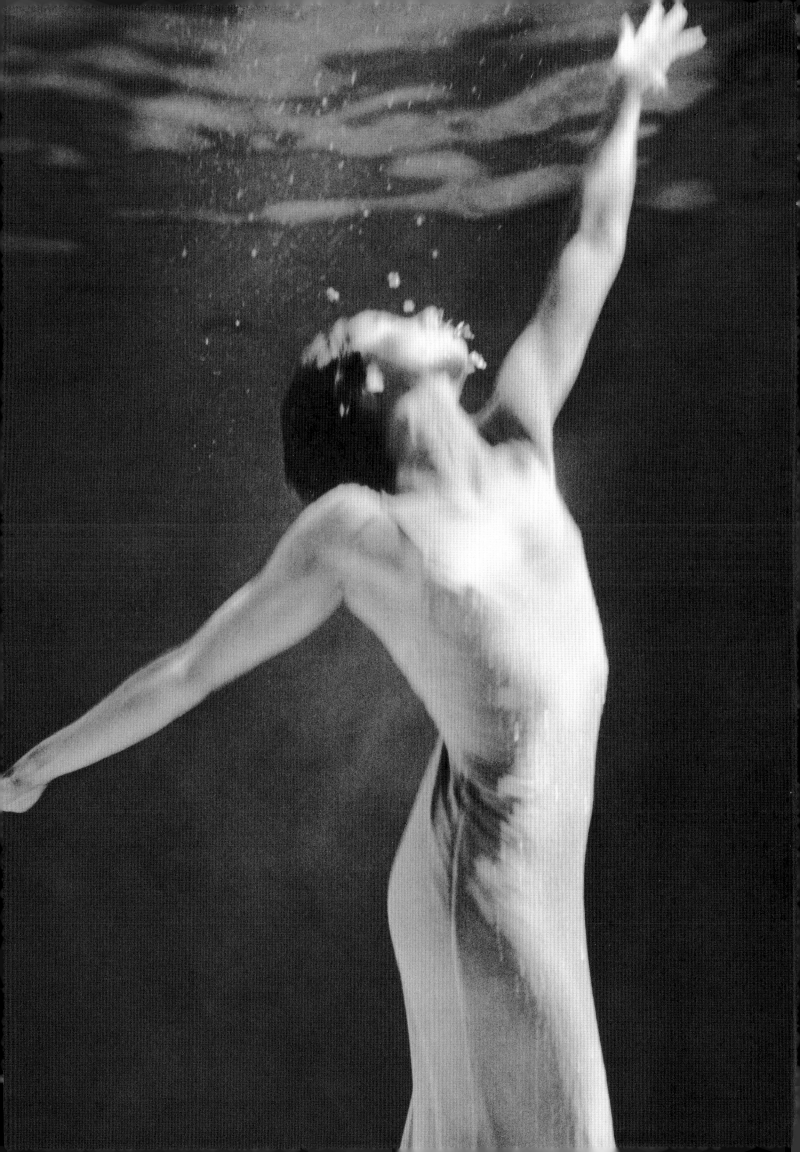

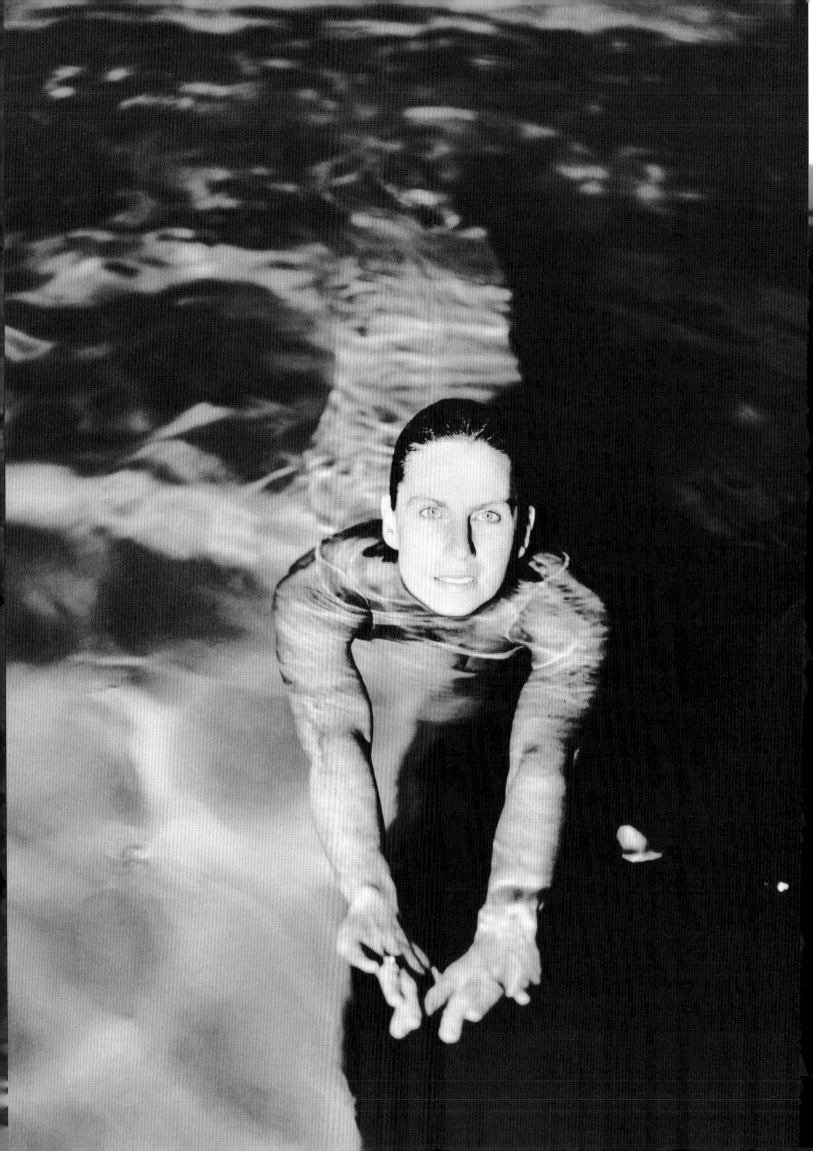

gatefold

CAROLYN WALDO
Olympic synchronized swimmer
two-time gold medallist
silver medallist

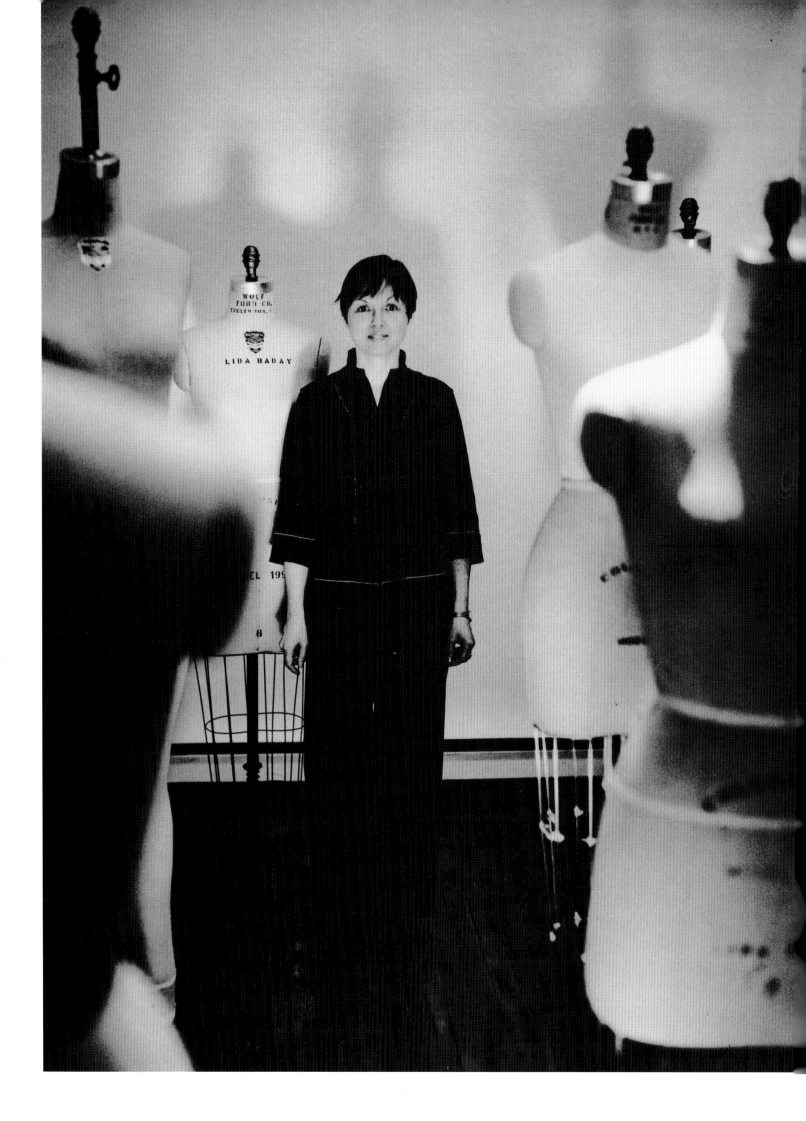

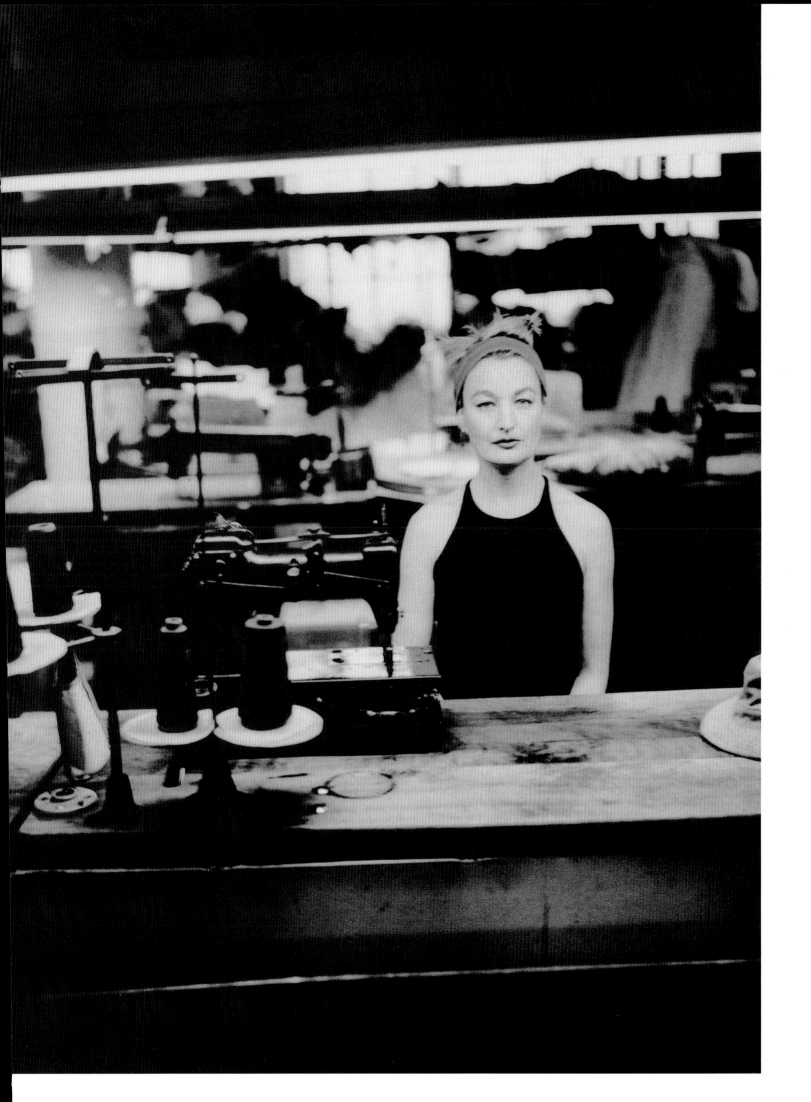

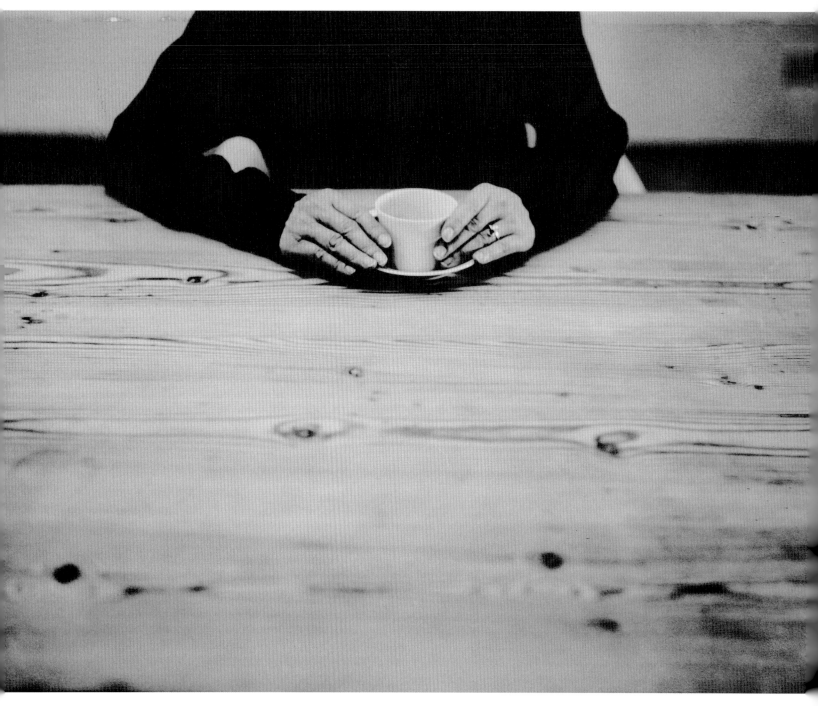

MARGARET ATWOOD
author

previous spread

left

LIDA BADAY
fashion designer

right

JANE SIBERRY
singer/songwriter/
record company owner

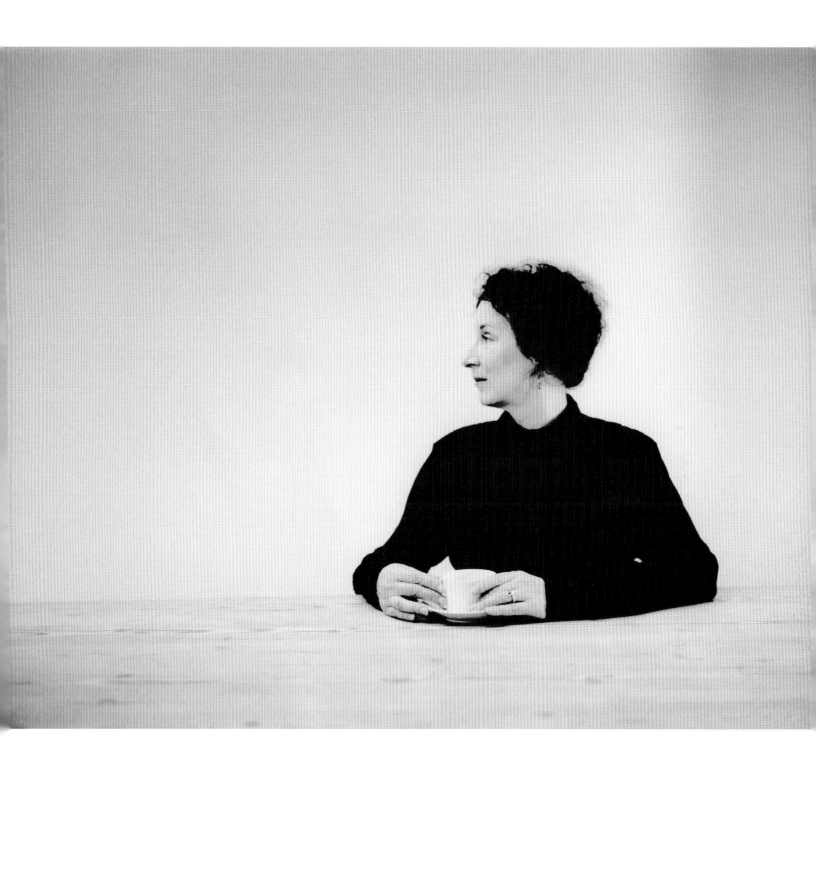

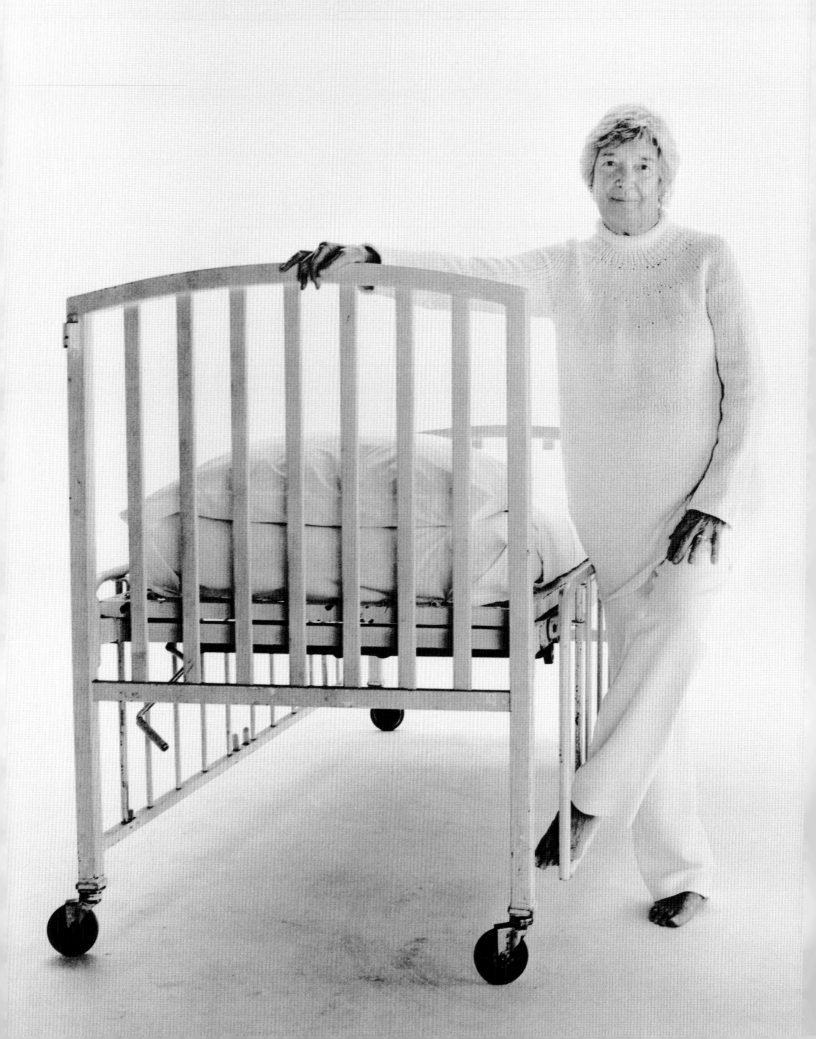

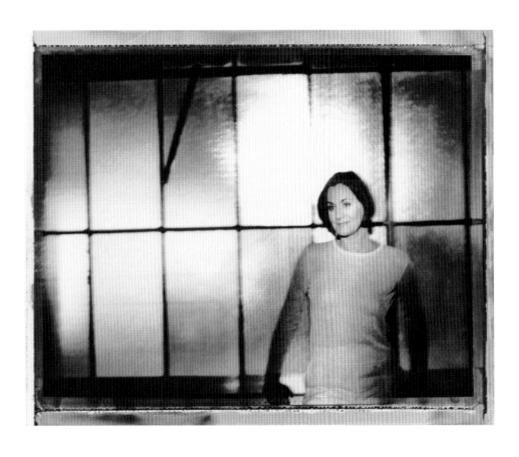

E-SINN SOONG
fashion designer

previous spread

left

JUNE CALLWOOD
journalist/Casey House
AIDS hospice founder

right

DENISE DONLON
vice-president/general manager
MuchMusic/MuchMoreMusic

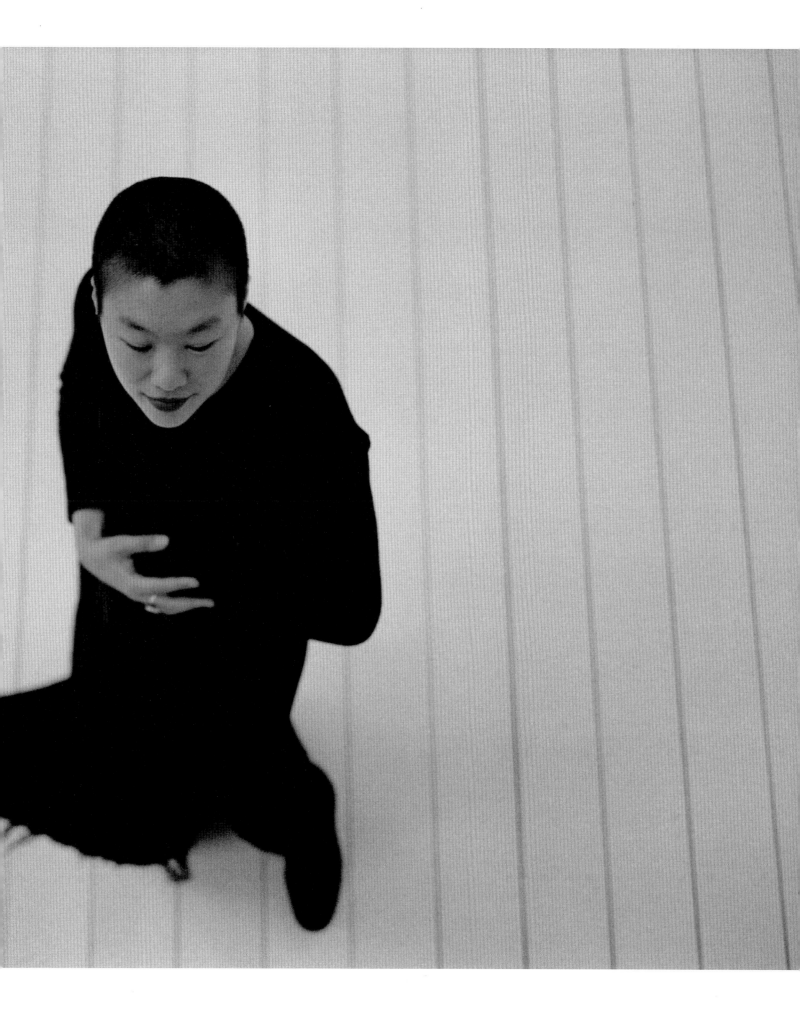

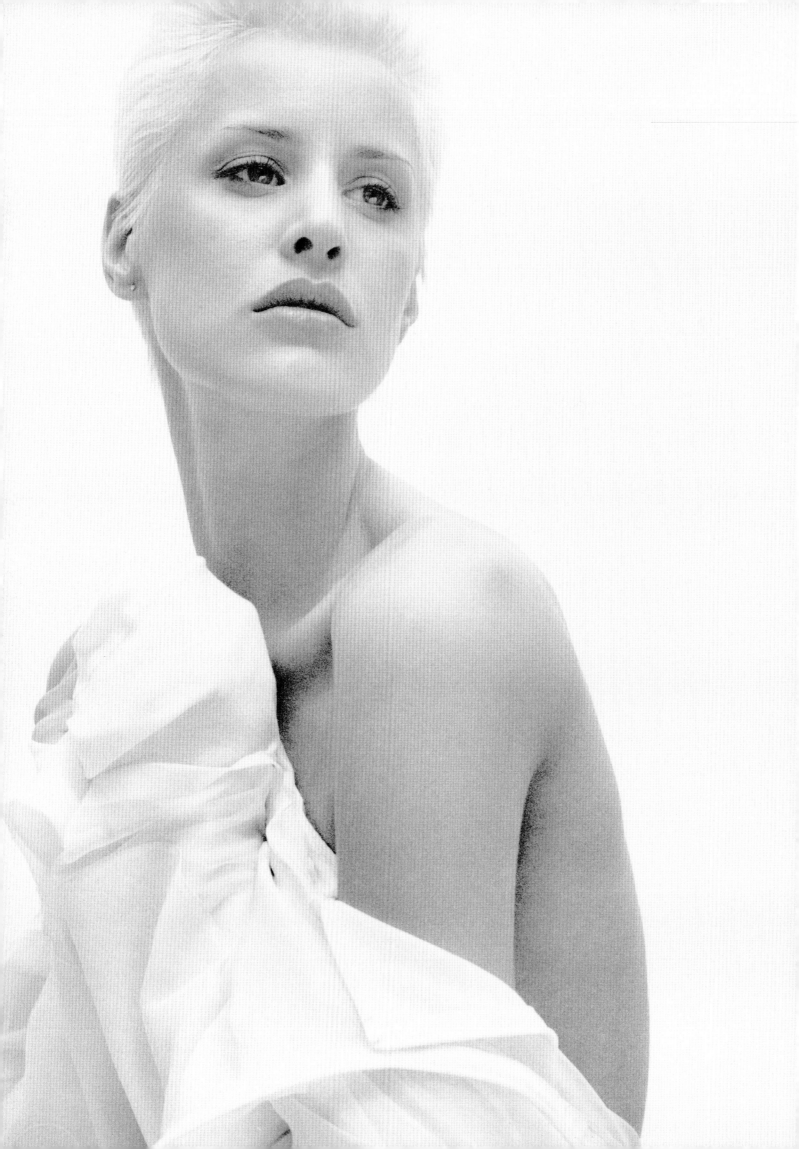

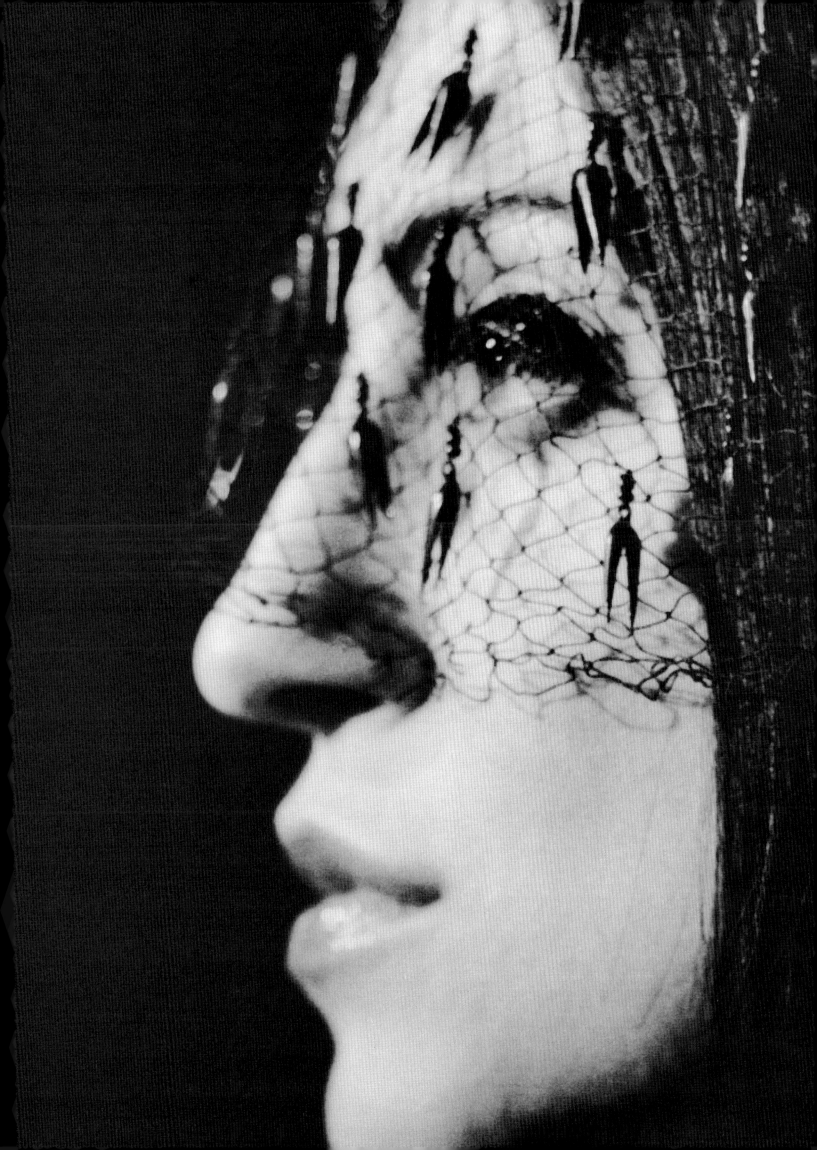

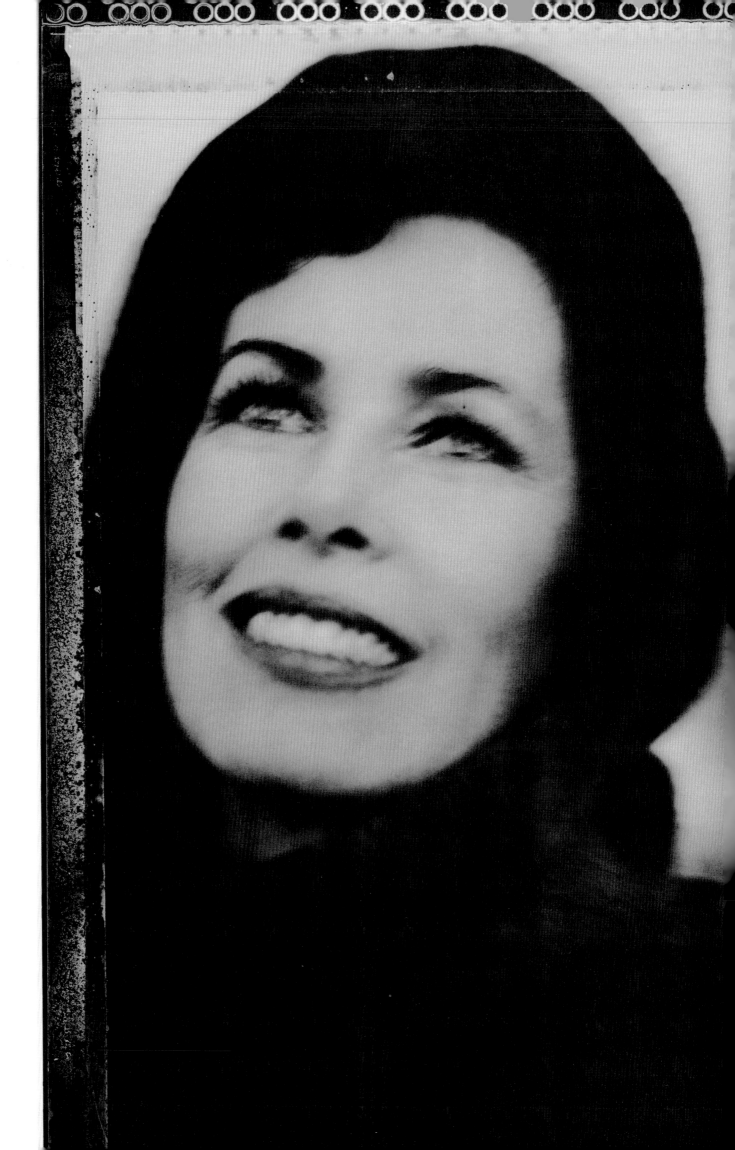

DAYLE HADDON
CEO/spokesmodel/author

previous spread

left
EVE SALVAIL
model

right
FLORIA SIGISMONDI
artist/director/photographer

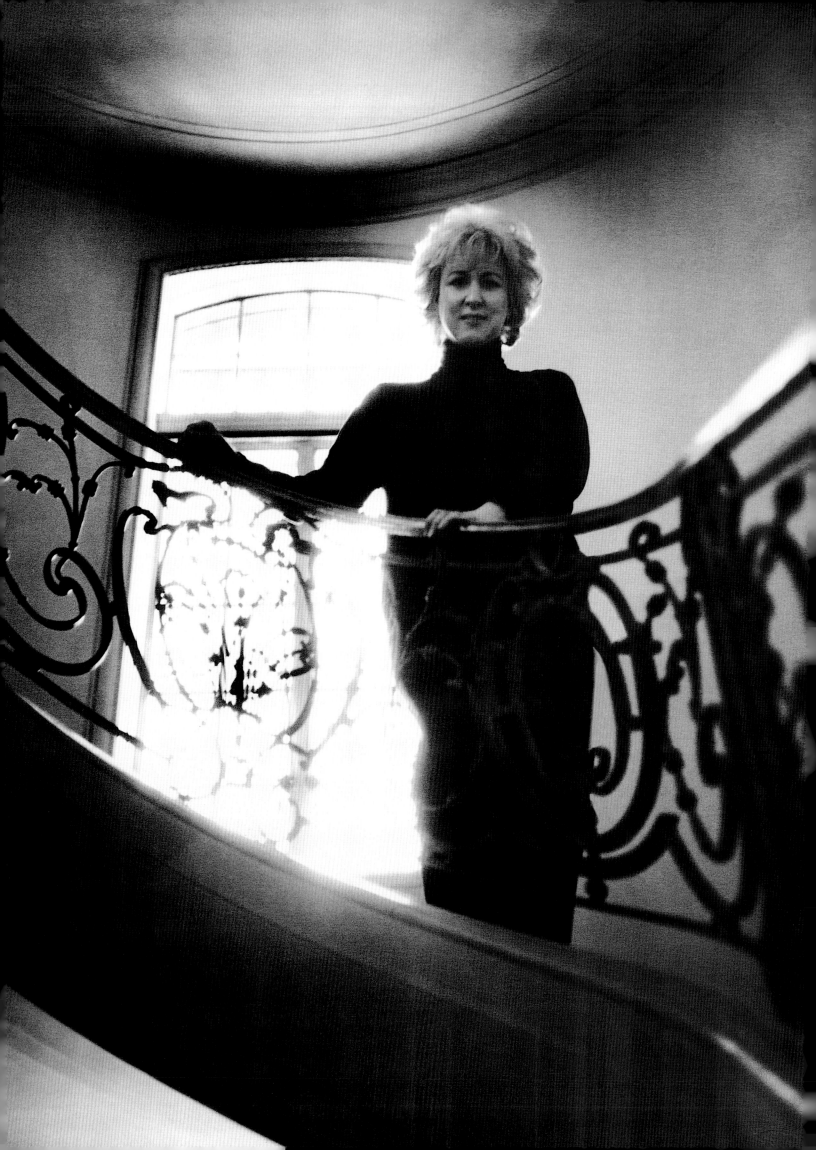

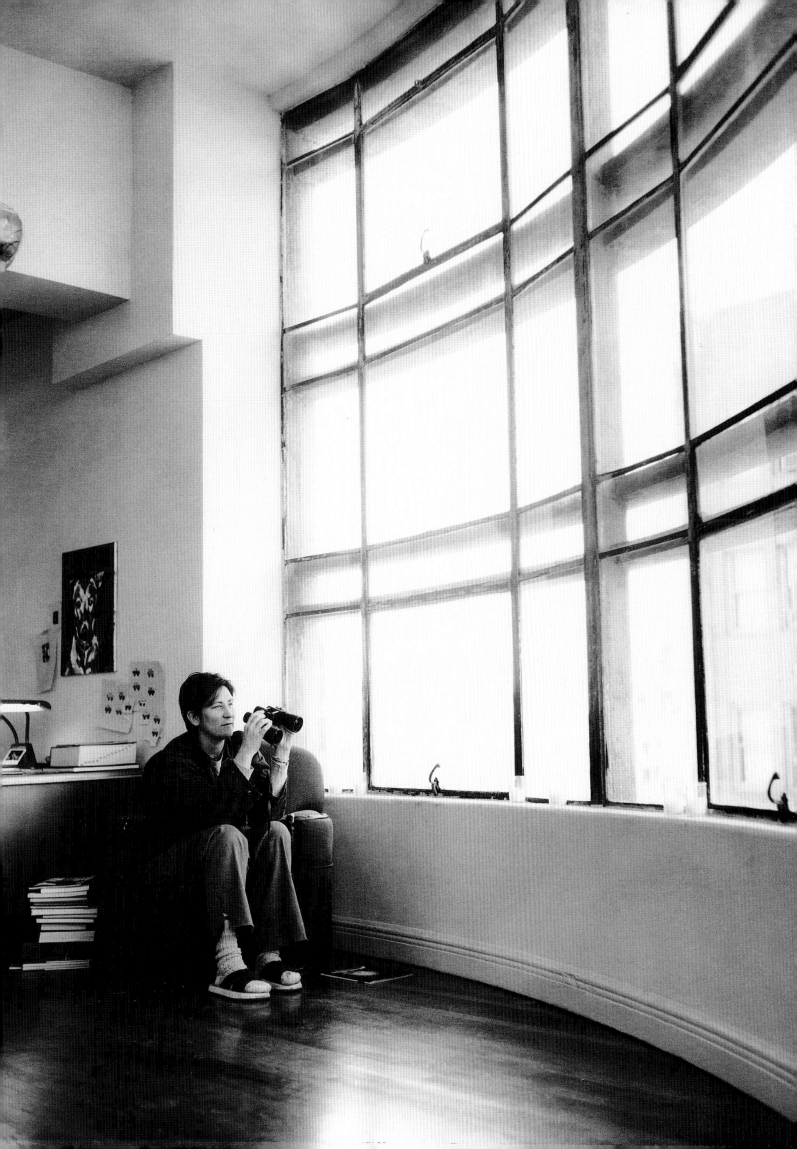

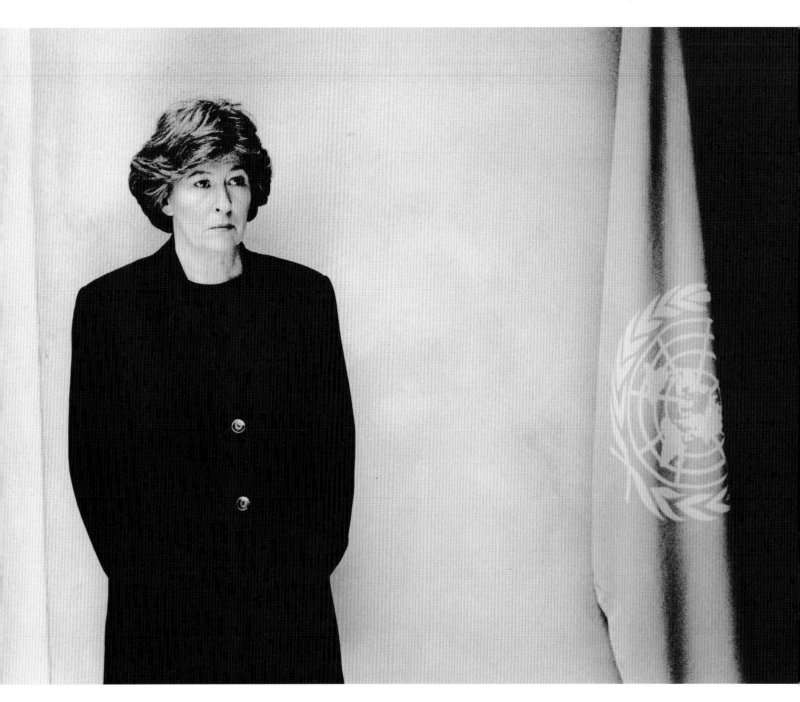

above

THE HONOURABLE MADAM JUSTICE LOUISE ARBOUR
Supreme Court of Canada
prosecutor, International Criminal Tribunal
for the former Yugoslavia and Rwanda

right

LIISA WINKLER
model

previous spread

left

THE RIGHT HONOURABLE KIM CAMPBELL
former prime minister of Canada,
consul general for Canada in Los Angeles

right

KD LANG
singer

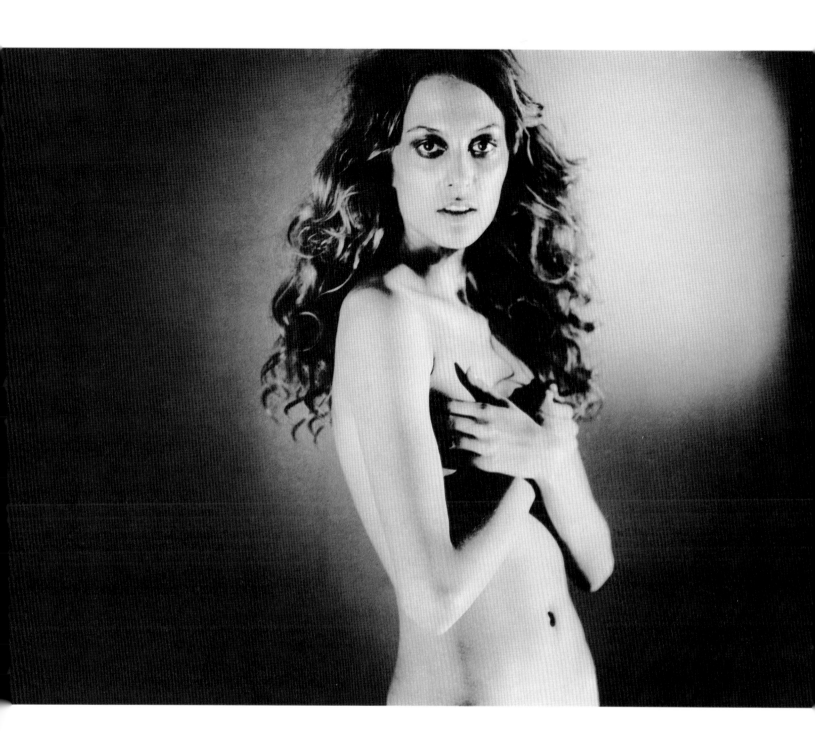

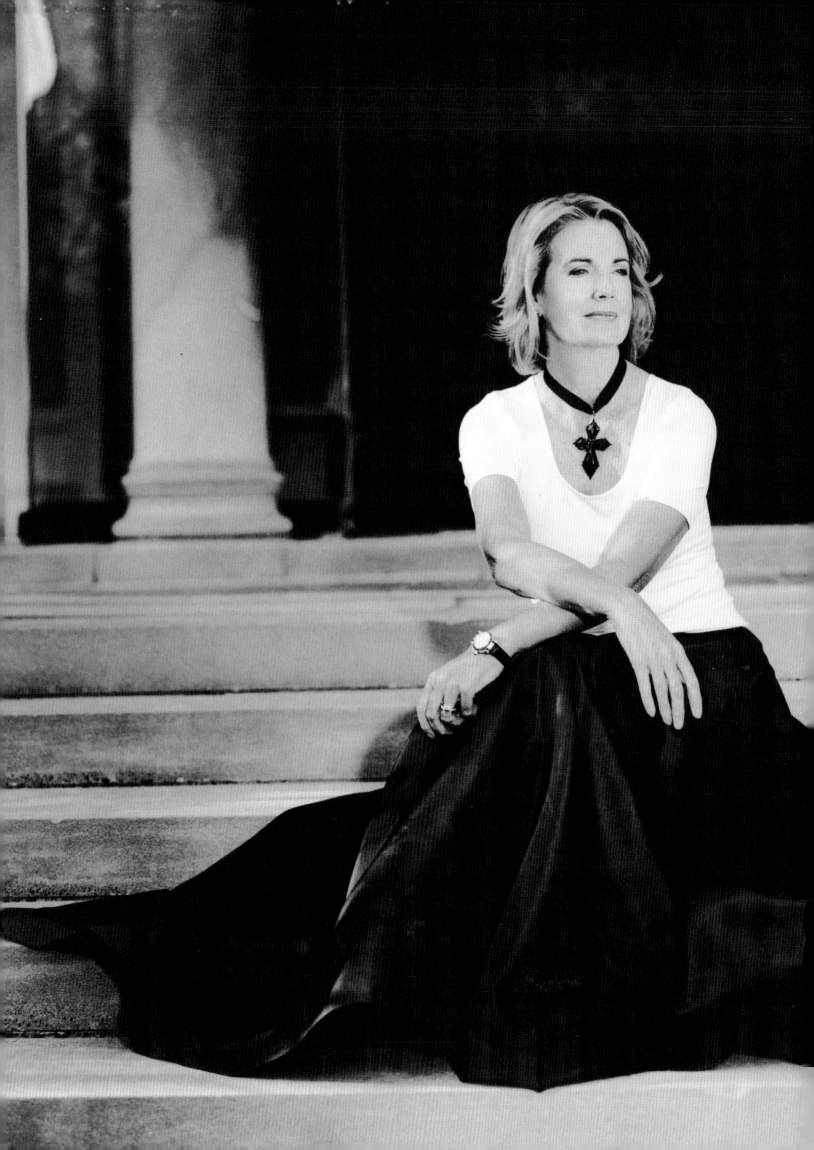

THE HON. HILARY M. WESTON
lieutenant-governor of Ontario

GENEVIÈVE BUJOLD
actor

following spread

left

CELINE DION
singer

right

CASSIE CAMPBELL
Olympic women's hockey player
silver medallist
member of Canada's national
women's hockey team

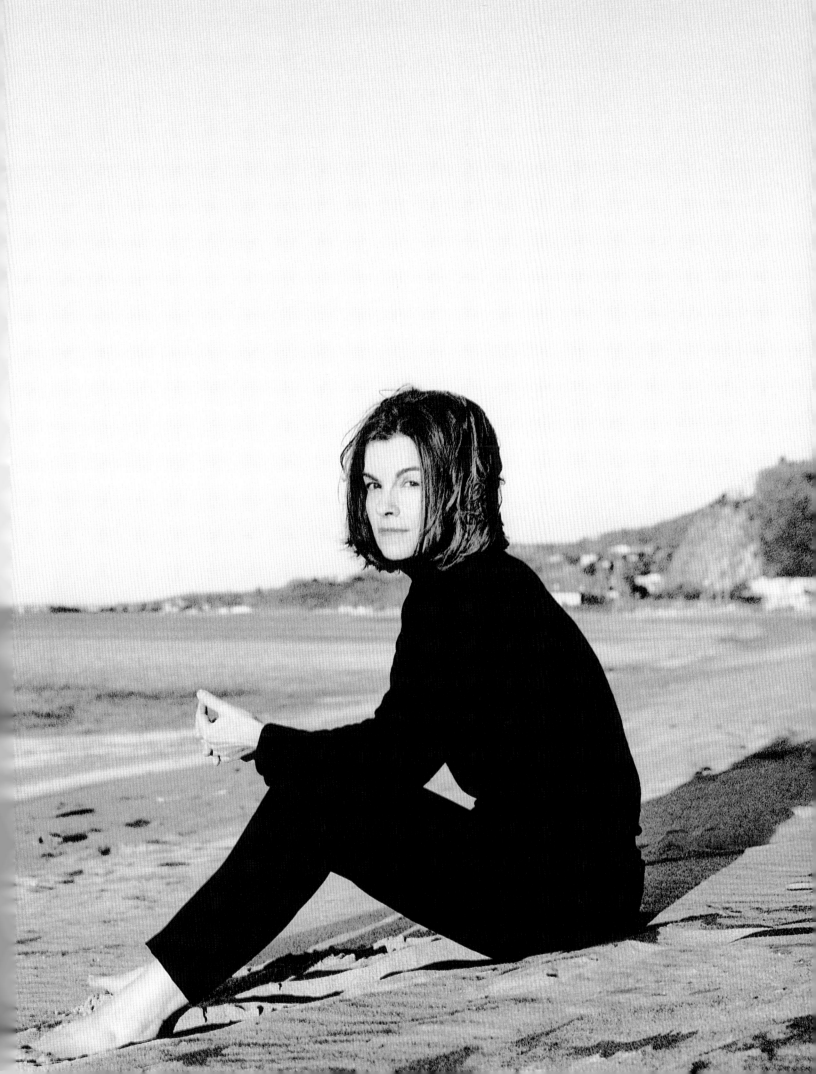

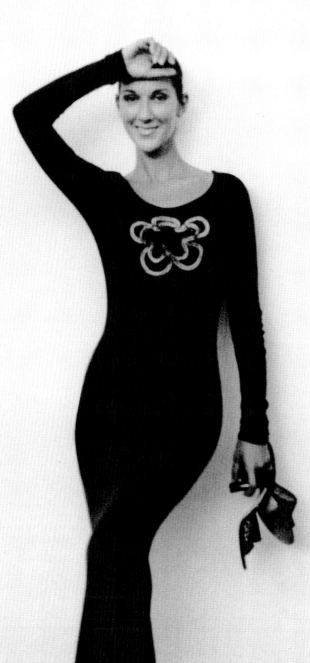

TOW-AWAY
ZONE
24
HRS.
7
DAYS
UNAUTHORIZED VEHICLES
WILL BE TOWED AWAY AT
OWNERS RISK & EXPENSE
MAGNUM TOWING INC.
324-5551
F.S. 715.07 / 713.78 M.C.# 9762

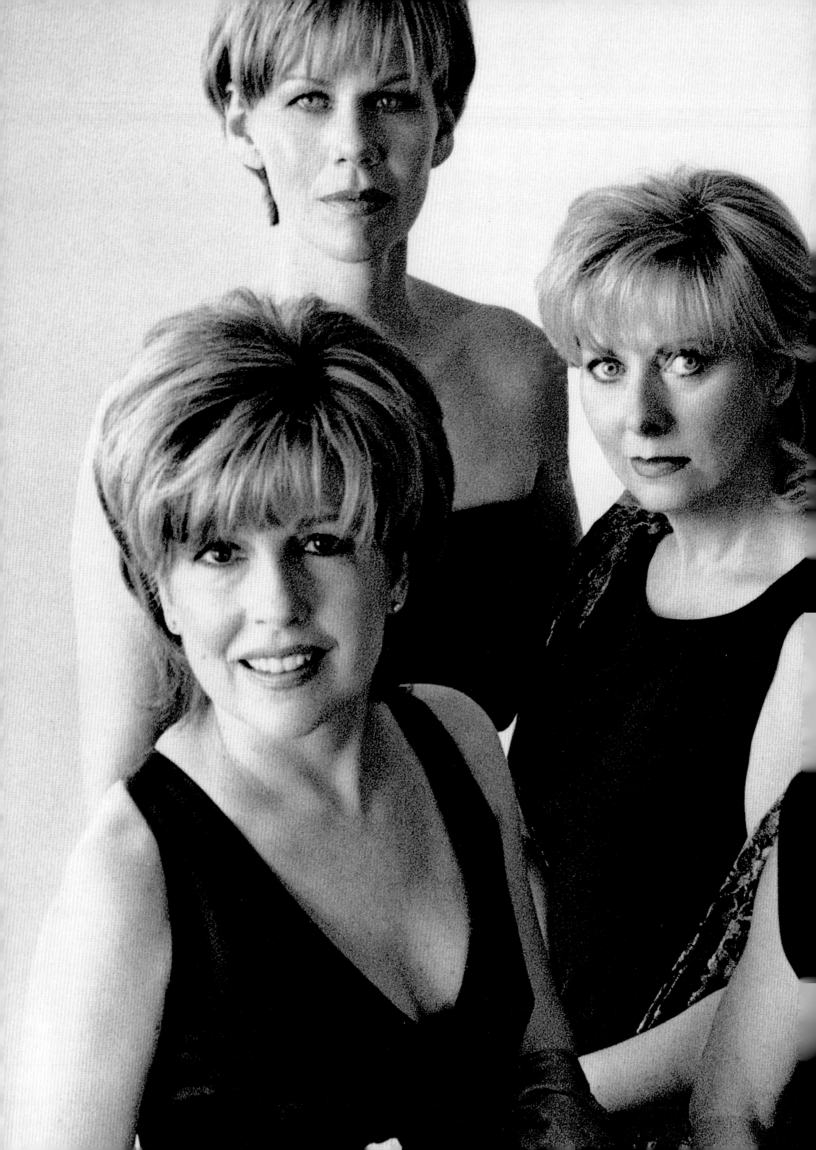

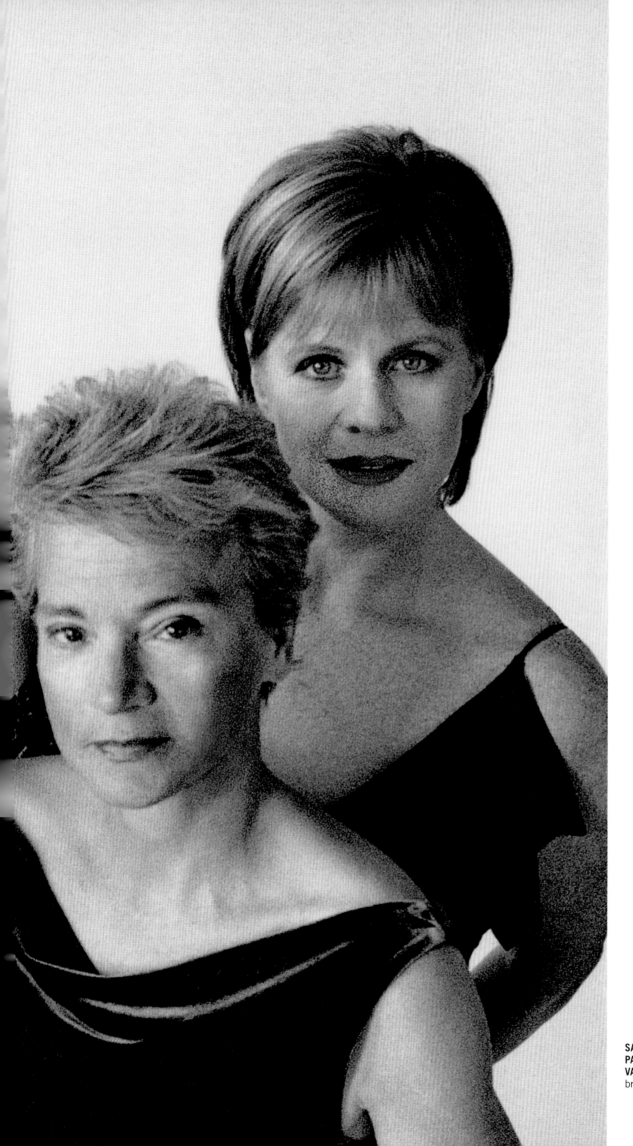

**SANDIE RINALDO, ALISON SMITH,
PAMELA WALLIN, ANN MEDINA AND
VALERIE PRINGLE**
broadcast journalists

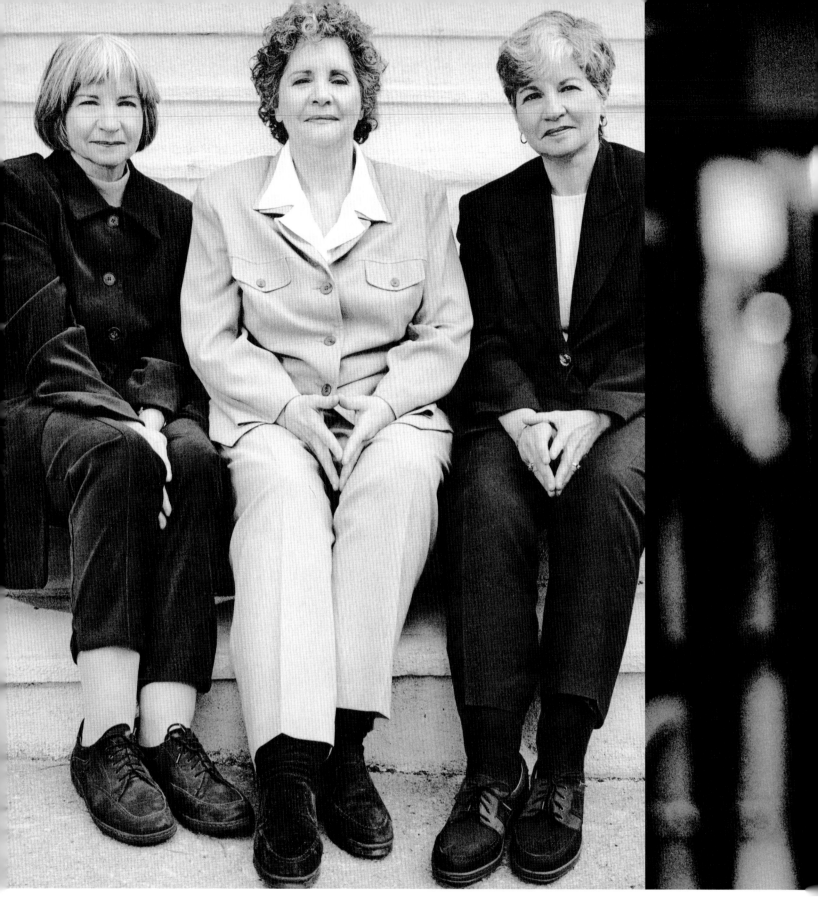

left
YVONNE, CÉCILE AND ANNETTE DIONNE
surviving Dionne quintuplets

right
ALICE MUNRO
author

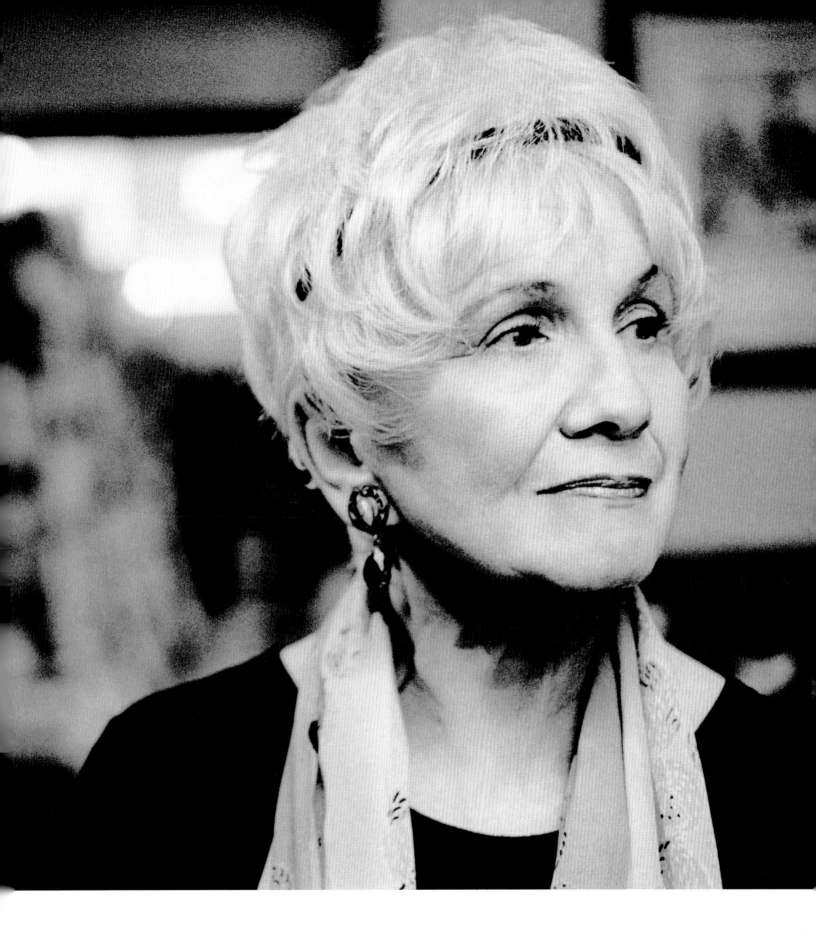

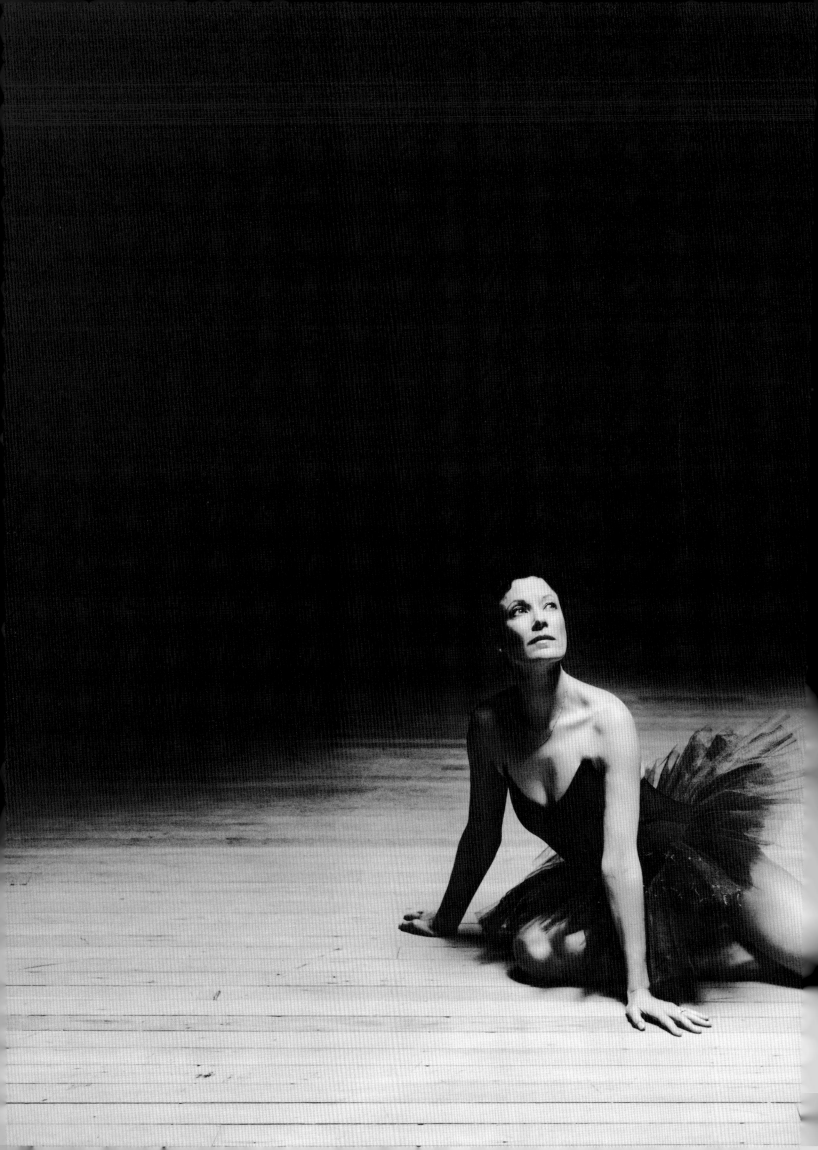

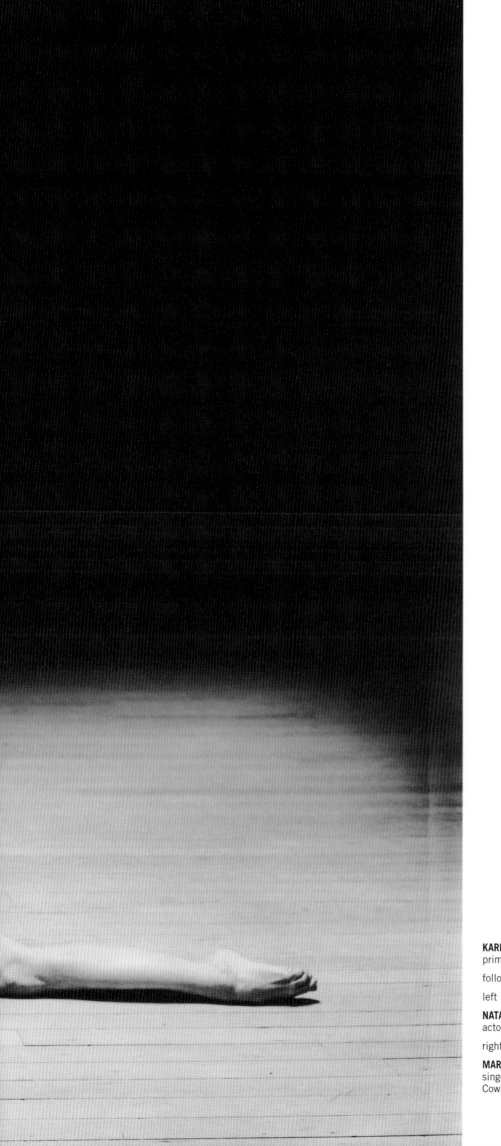

KAREN KAIN
prima ballerina

following spread

left

NATASHA HENSTRIDGE
actor

right

MARGO TIMMINS
singer
Cowboy Junkies

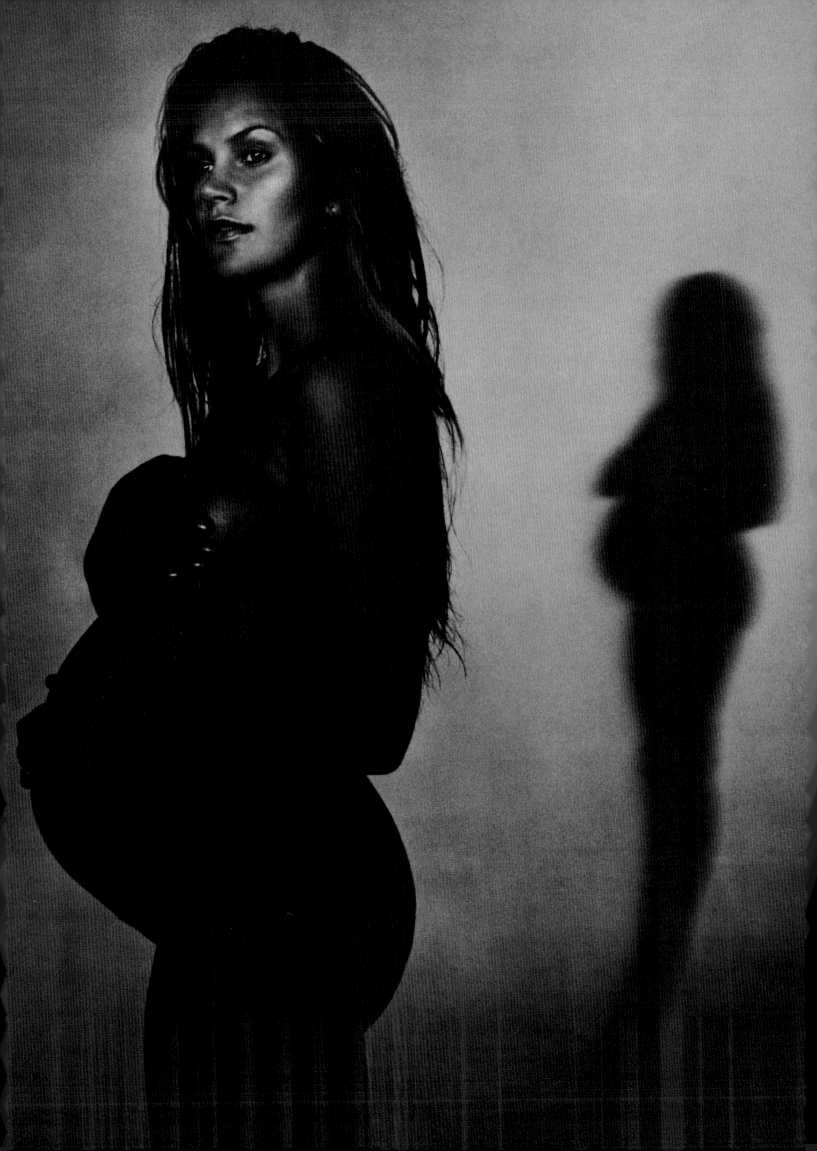

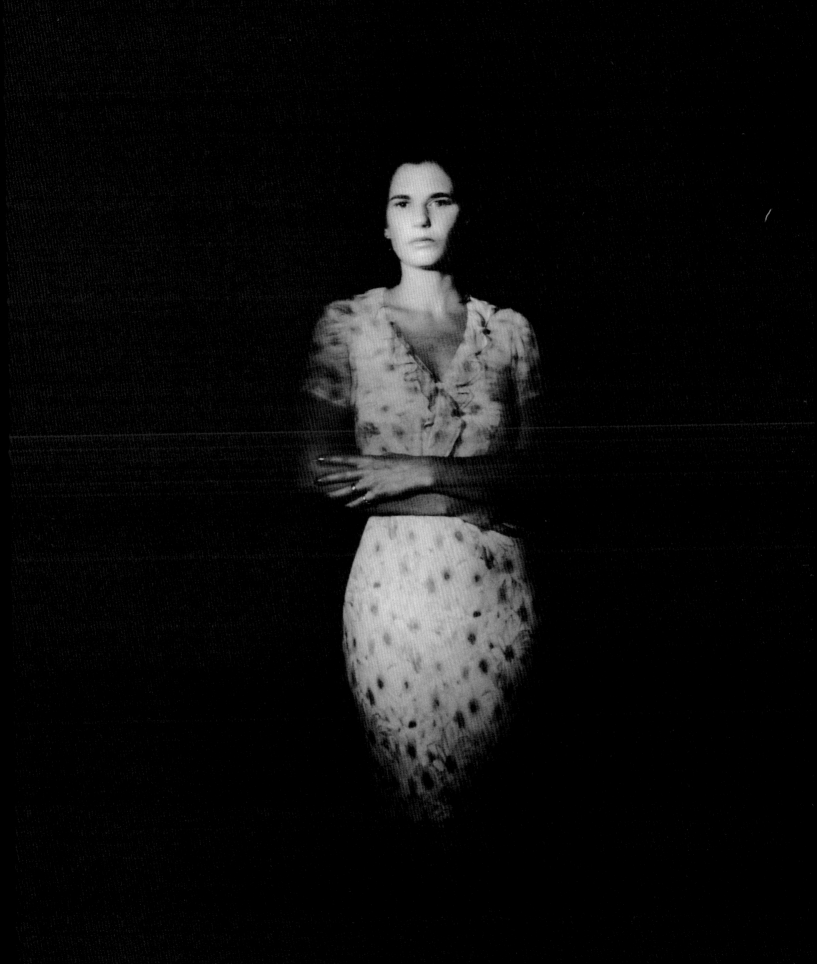

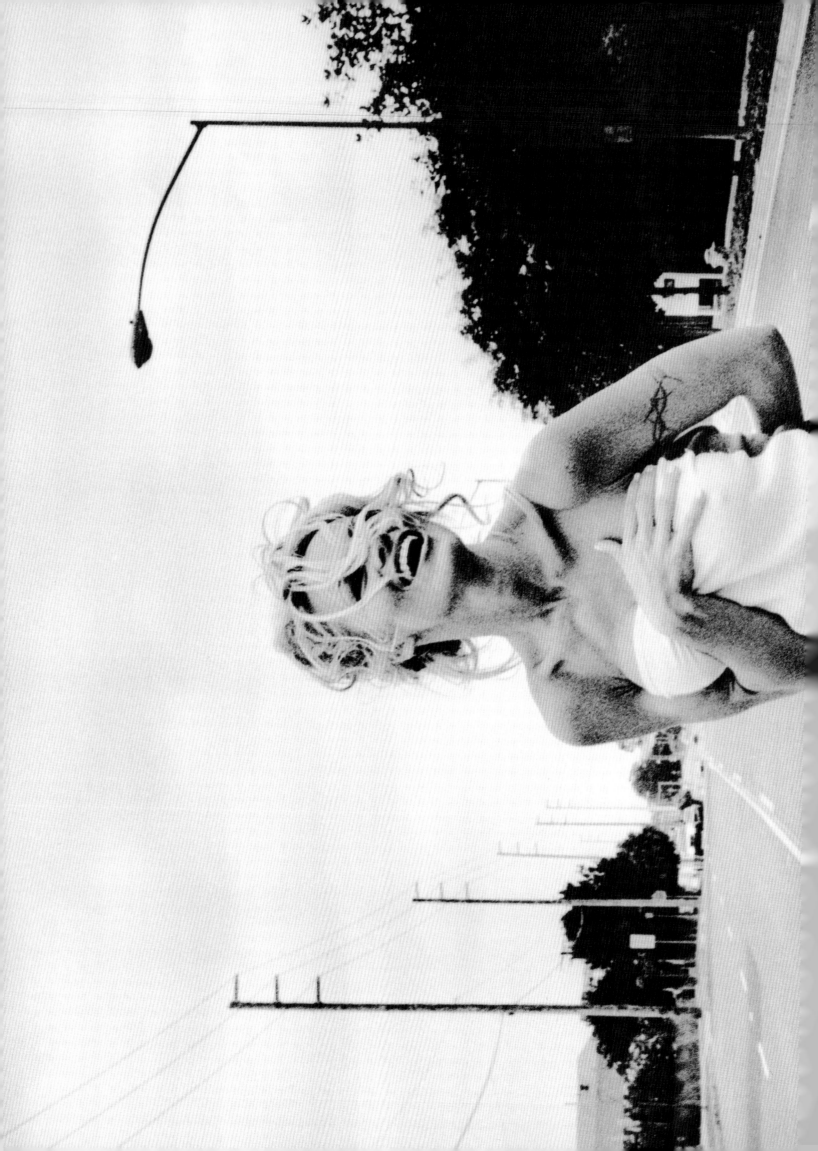

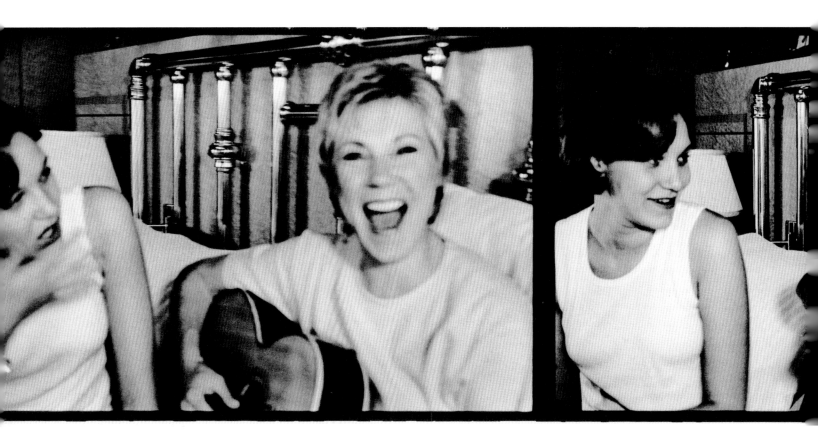

ANNE MURRAY
singer

DAWN LANGSTROTH
daughter

centerfold

PAMELA ANDERSON LEE
actor

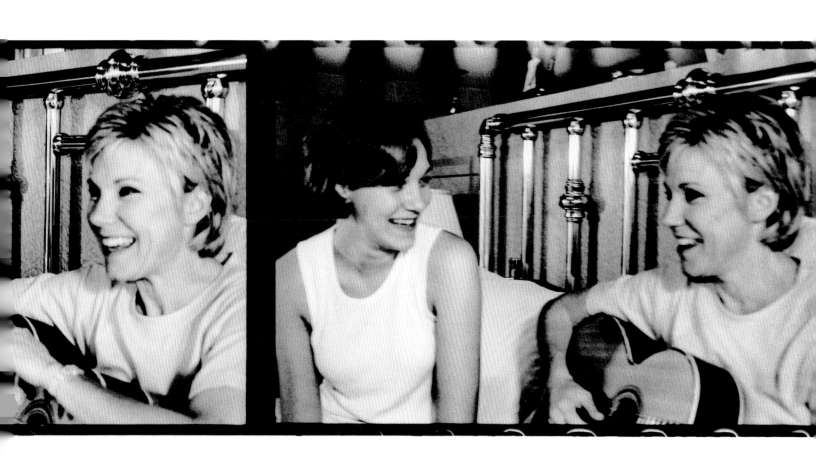

LOIS MAXWELL
Miss Moneypenny
writer/actor

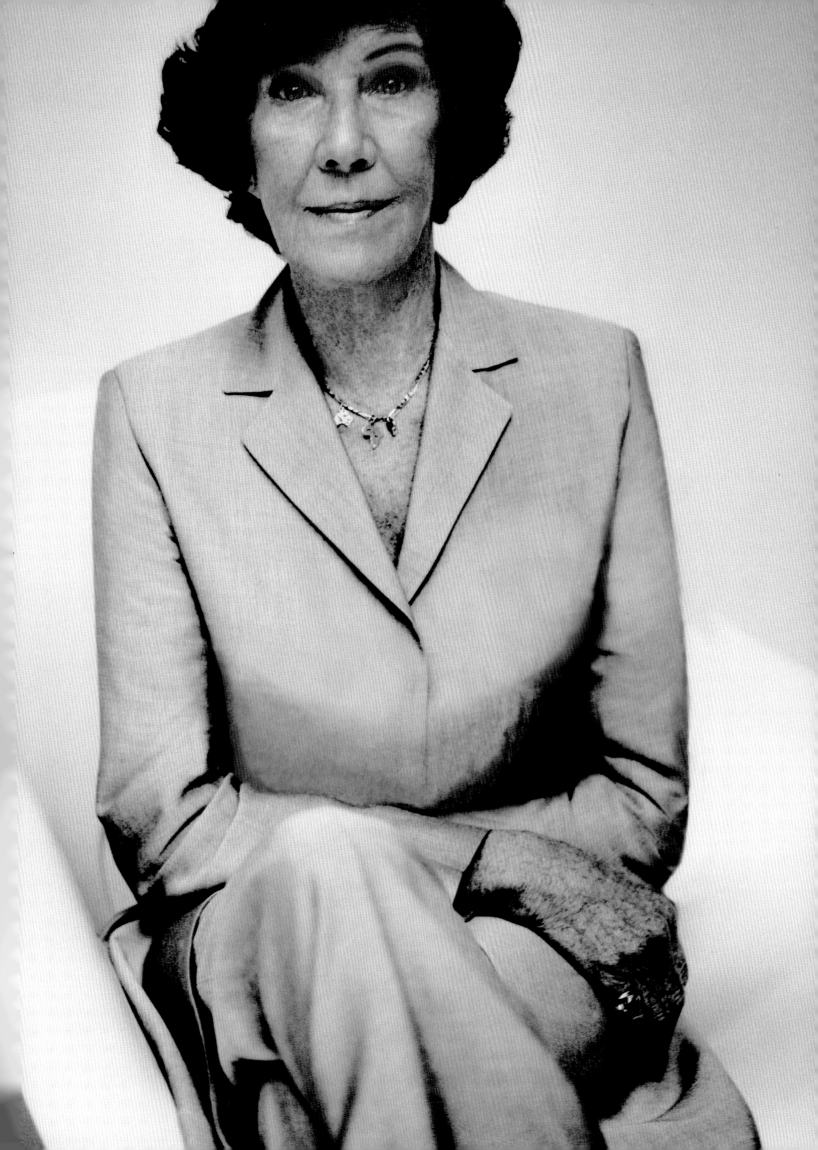

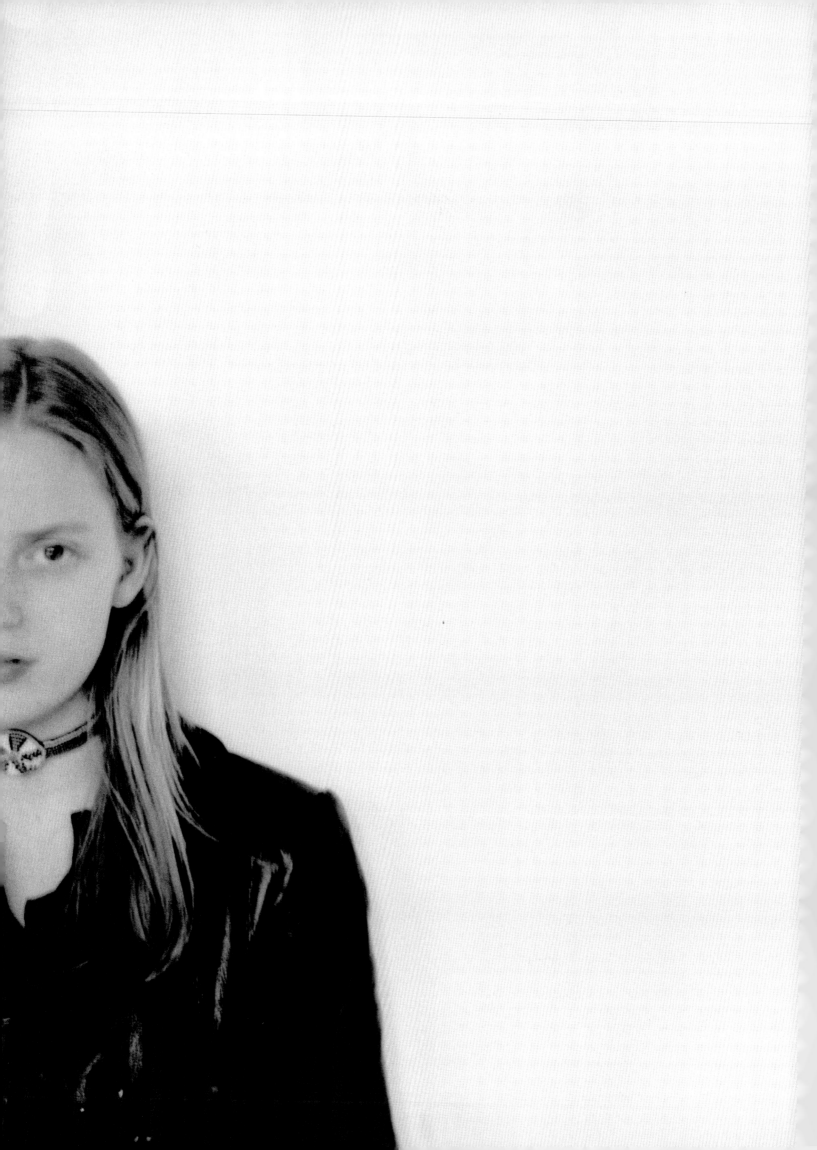

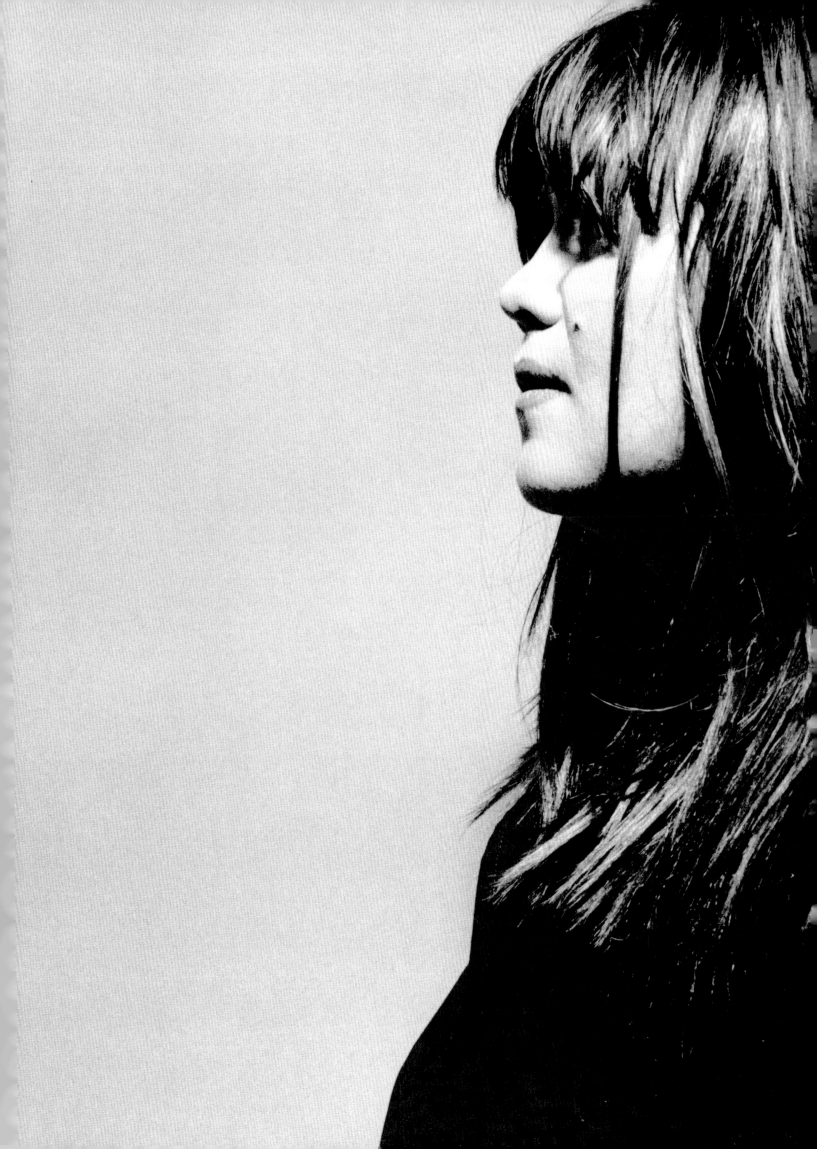

BONNIE FULLER
magazine editor-in-chief

previous spread

left

SARAH POLLEY
actor/activist

right

JANN ARDEN
singer/songwriter

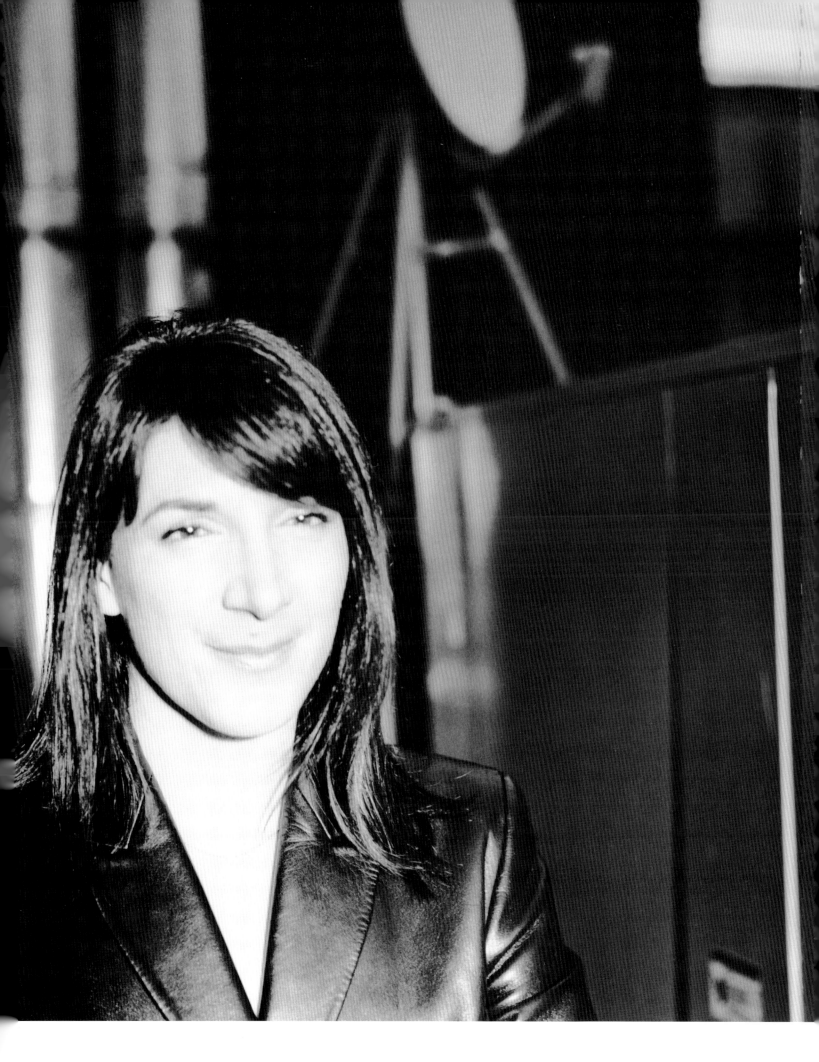

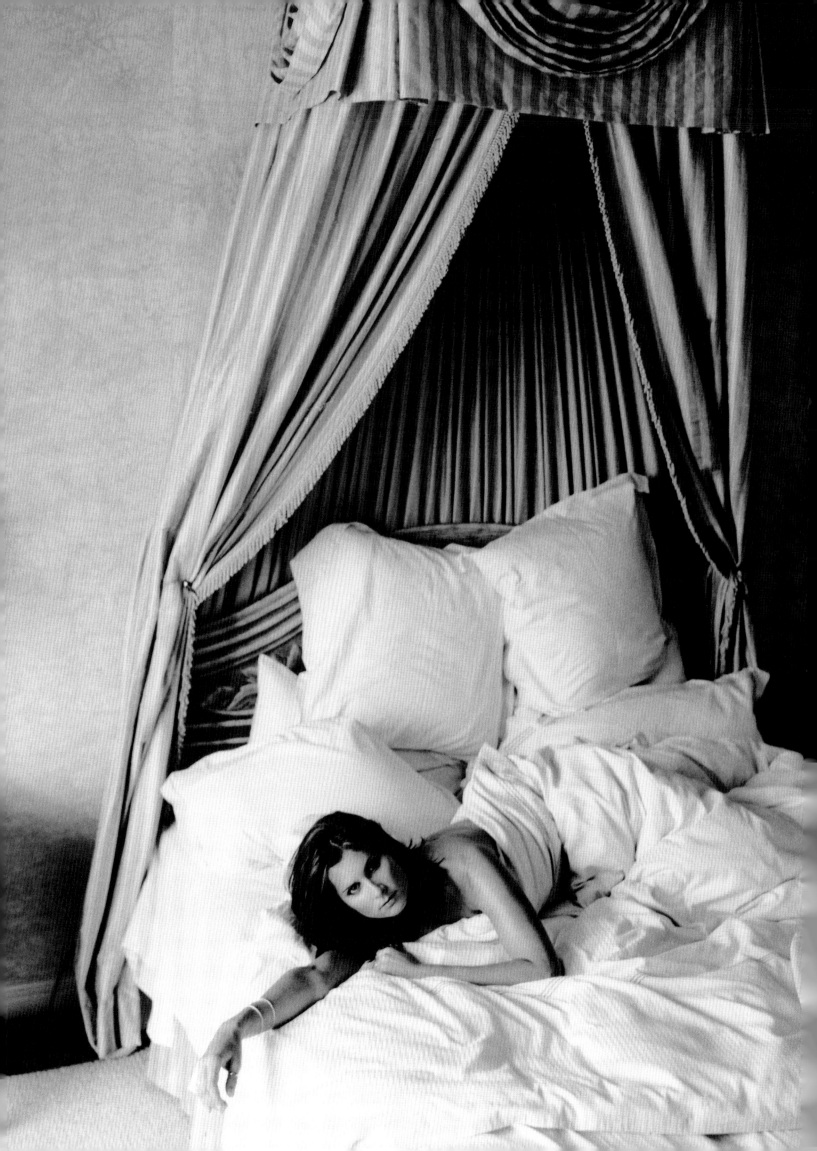

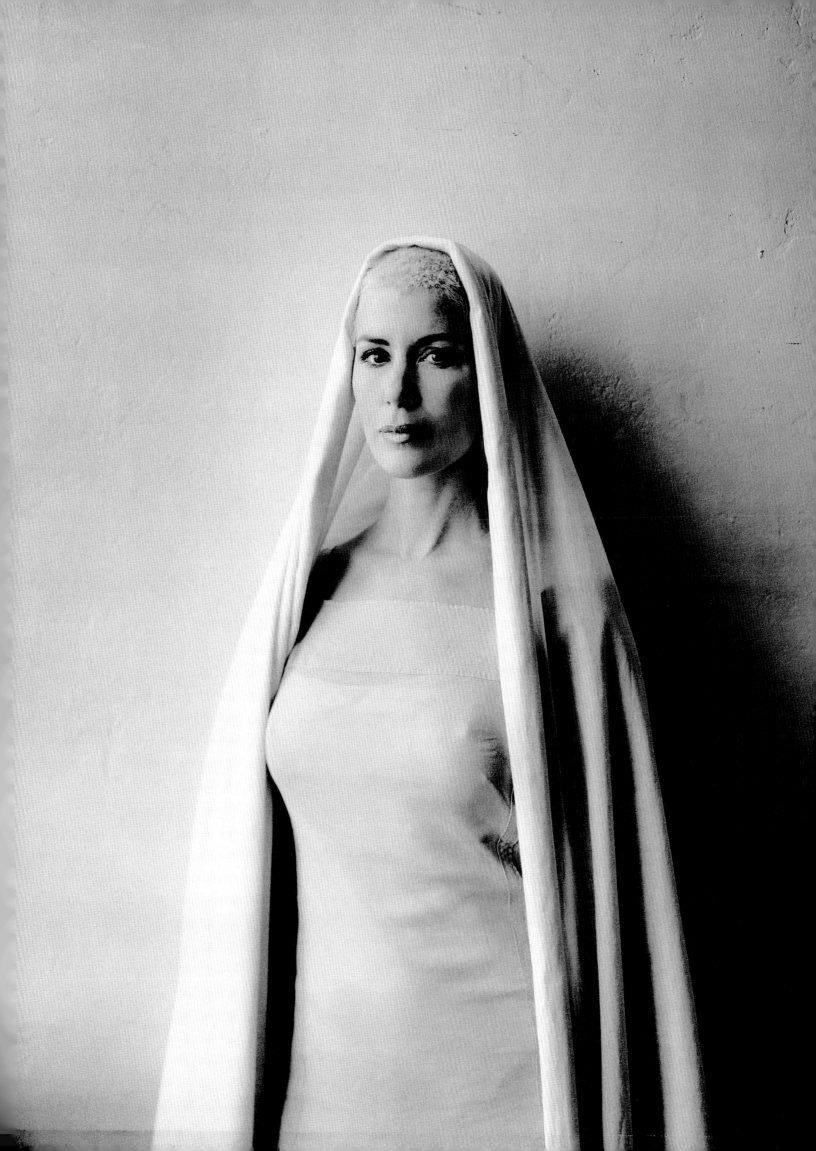

TONYA LEE WILLIAMS
actor/entrepreneur

previous spread

left

TERRI CLARK
singer/songwriter

right

SONJA SMITS
actor

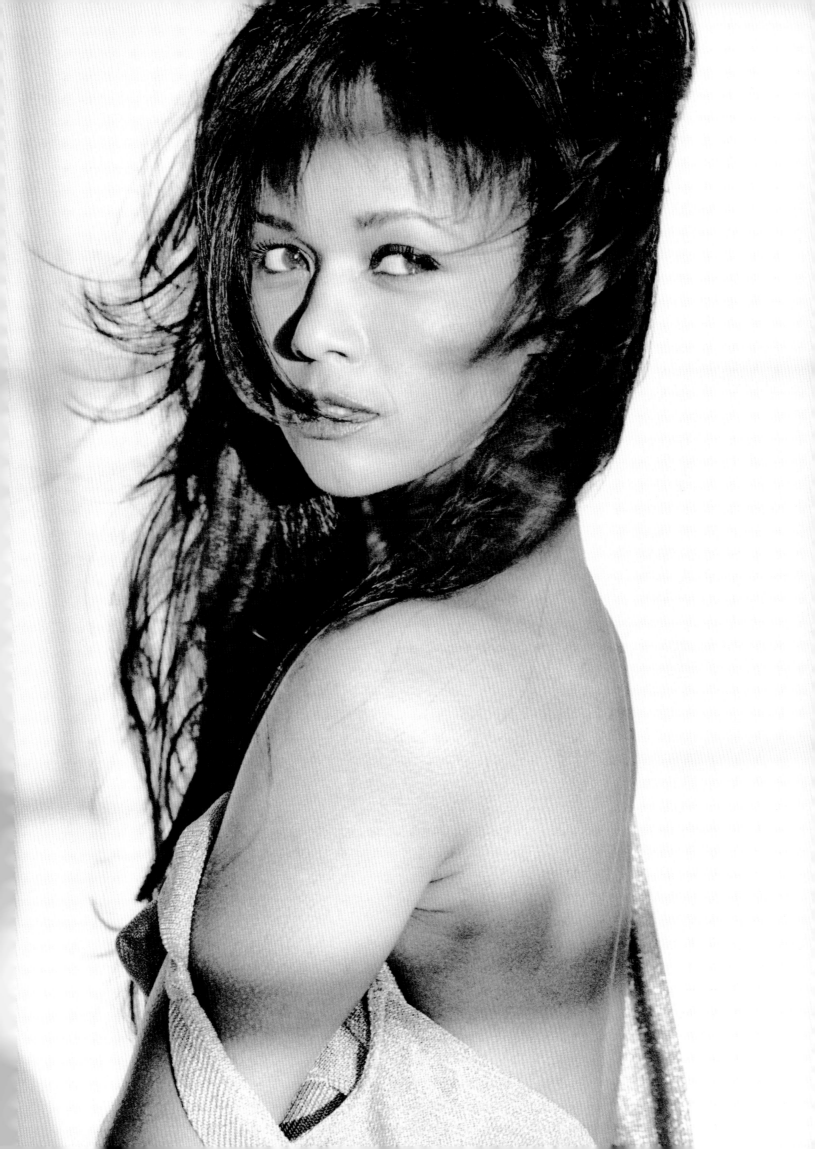

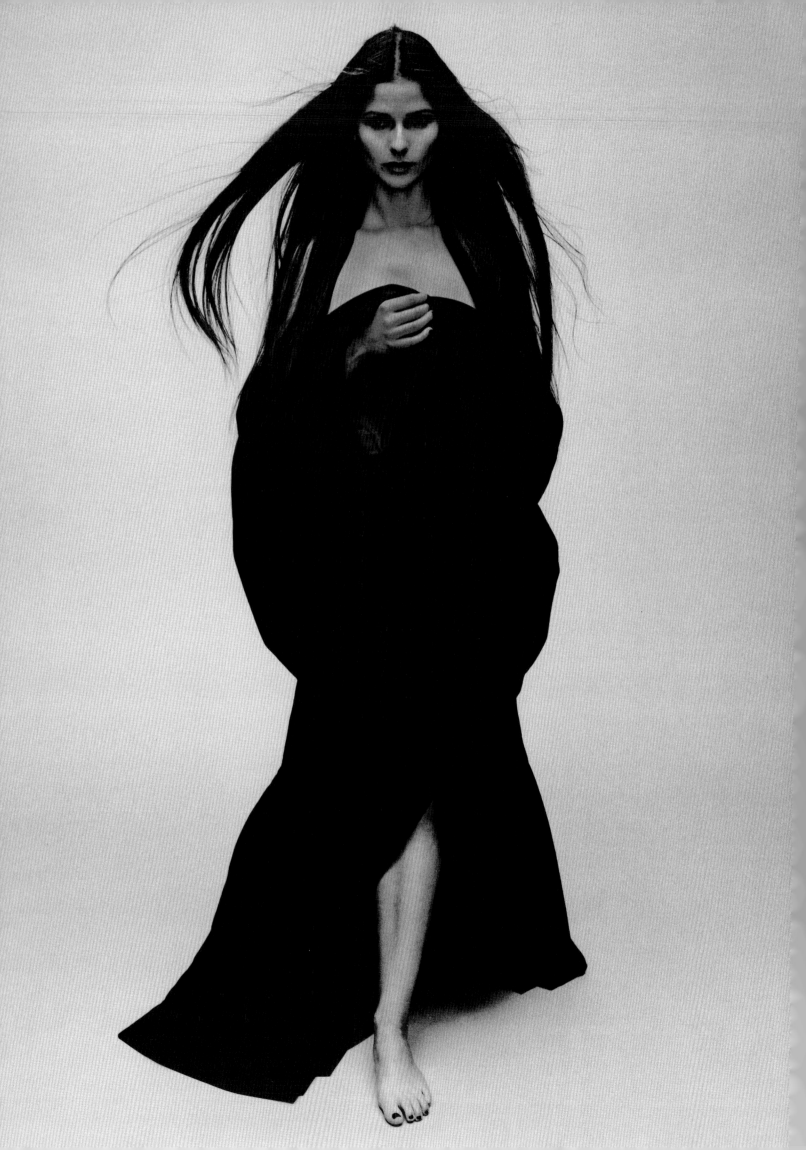

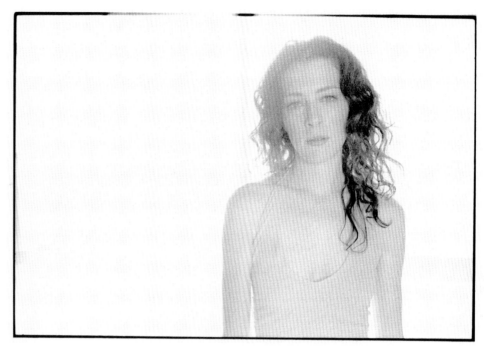

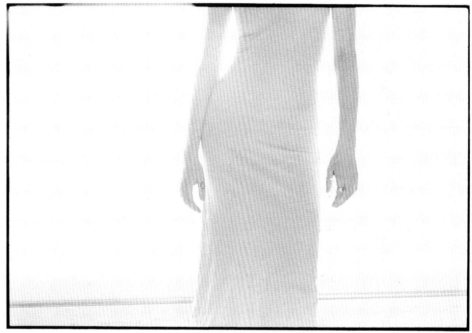

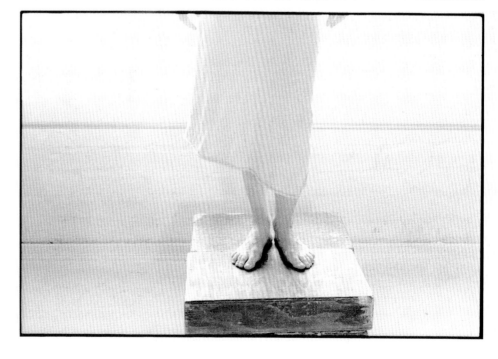

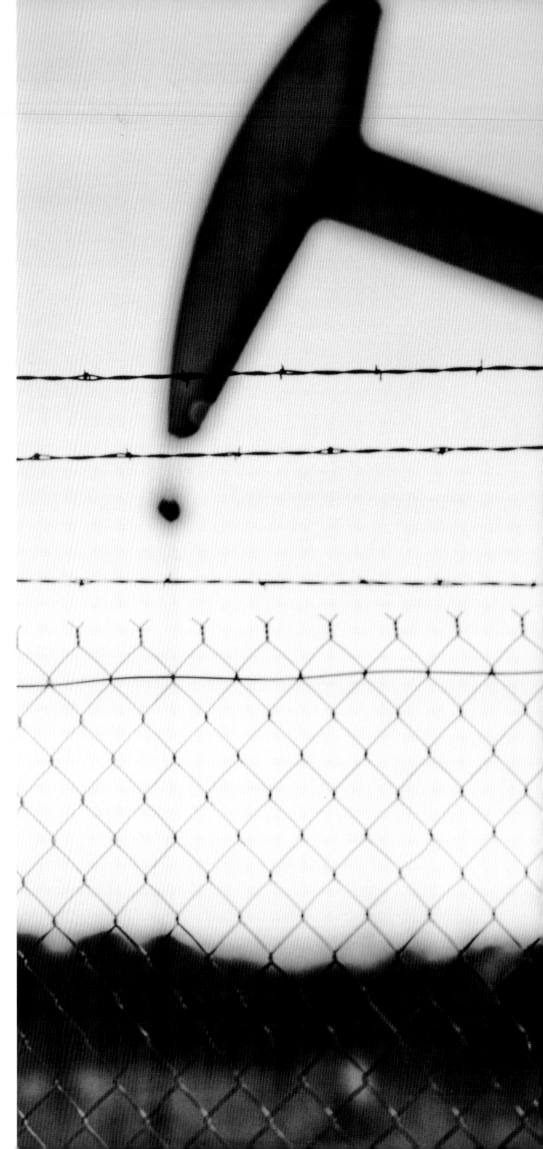

TRICIA HELFER
model

previous spread

left

JILL HENNESSY
actor/director

right

MELISSA AUF DER MAUR
musician, Hole/photographer

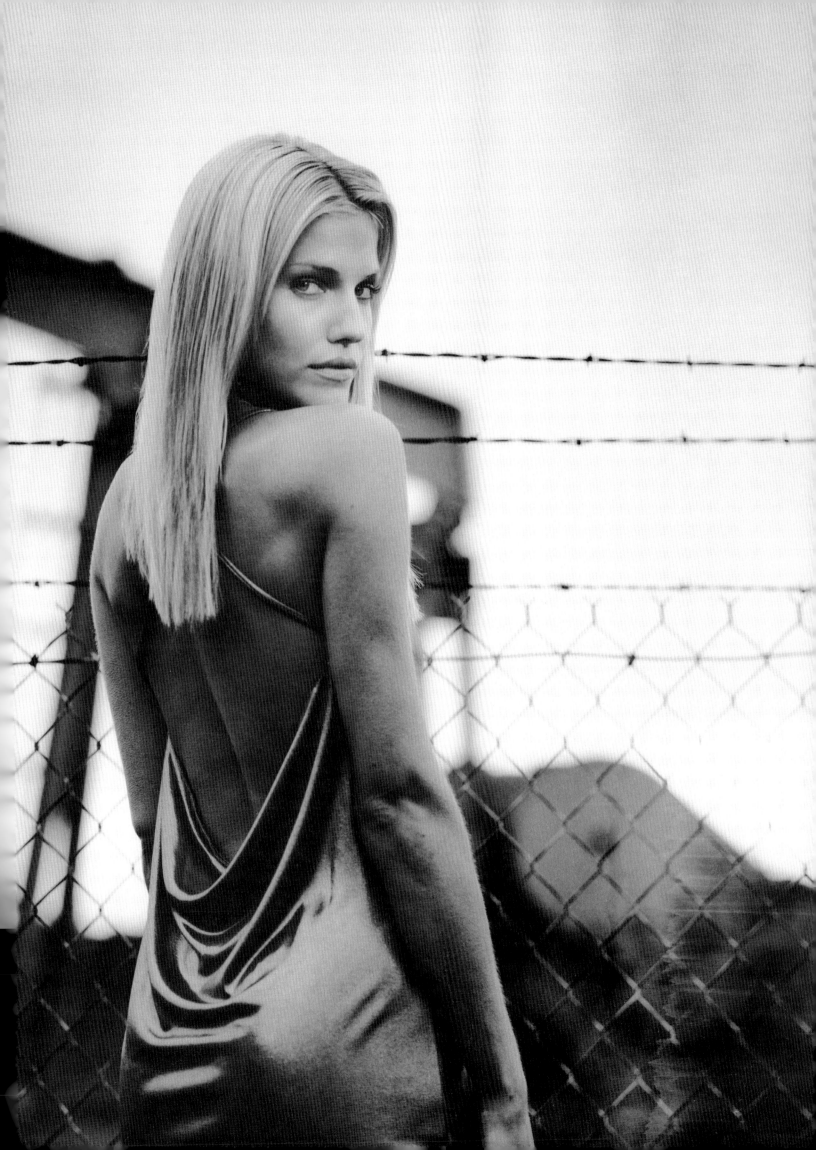

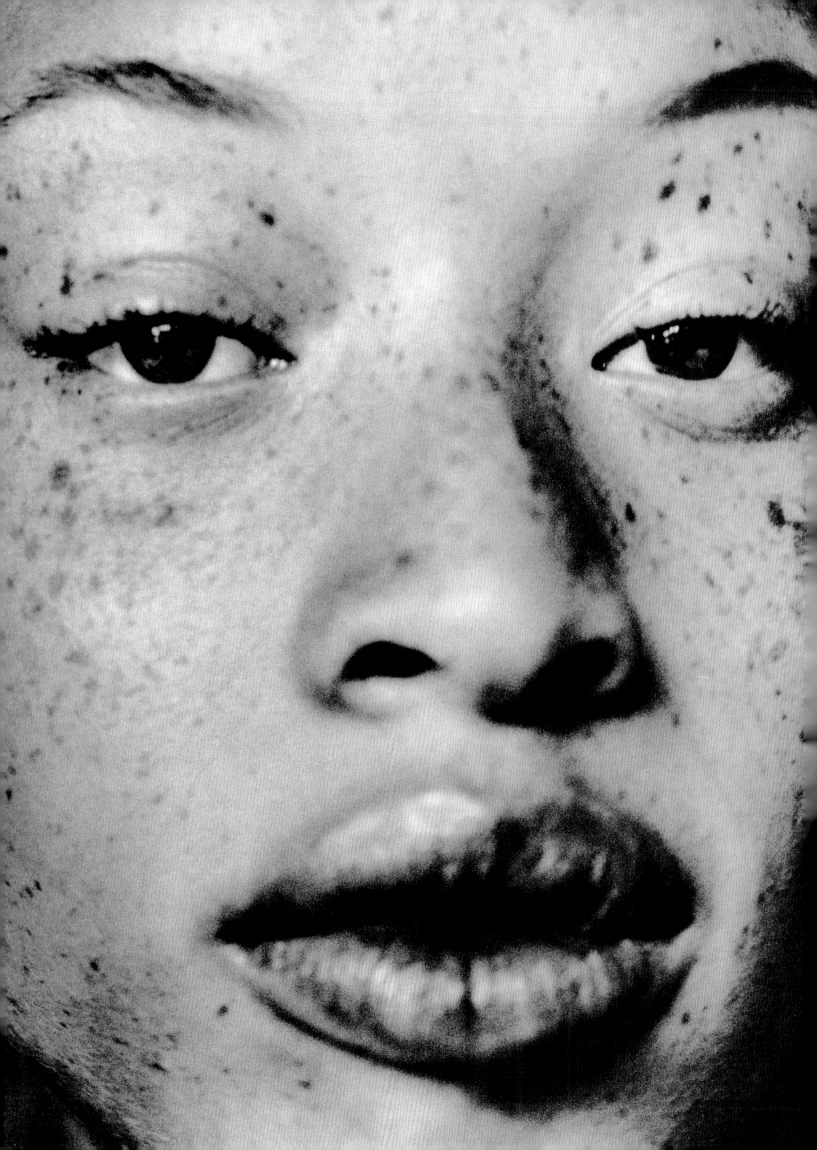

STACEY MCKENZIE
model

LINDA EVANGELISTA
model

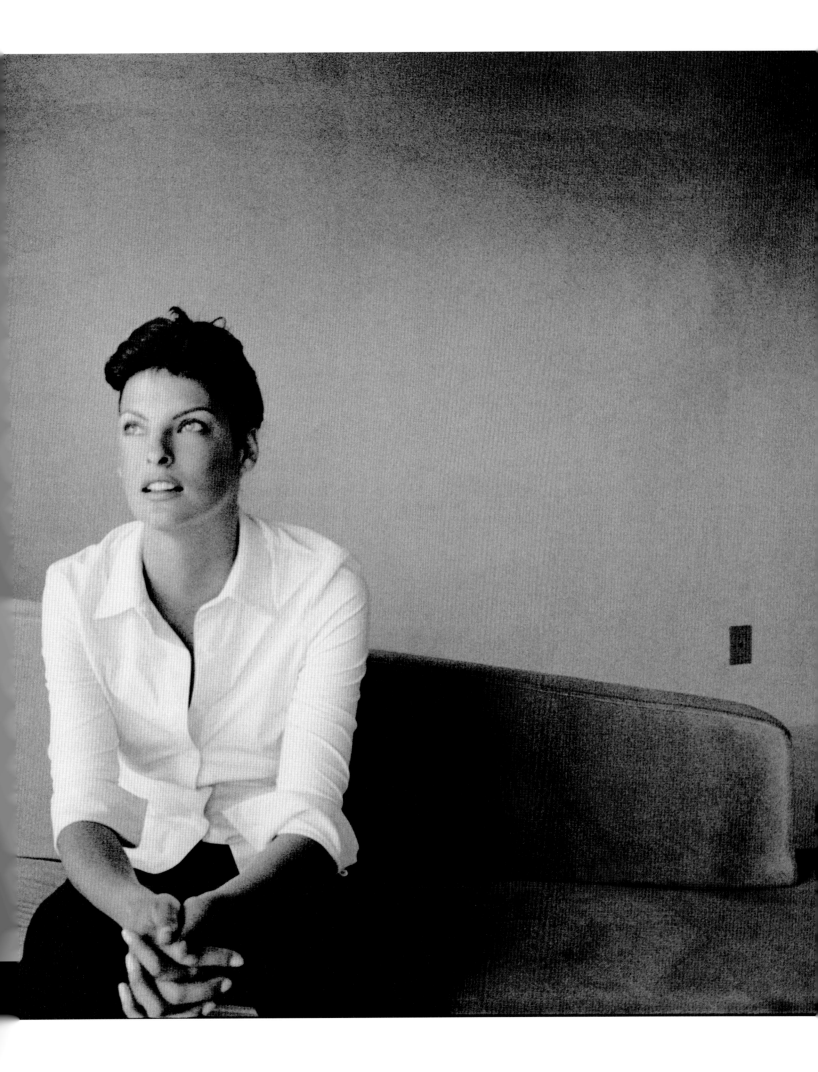

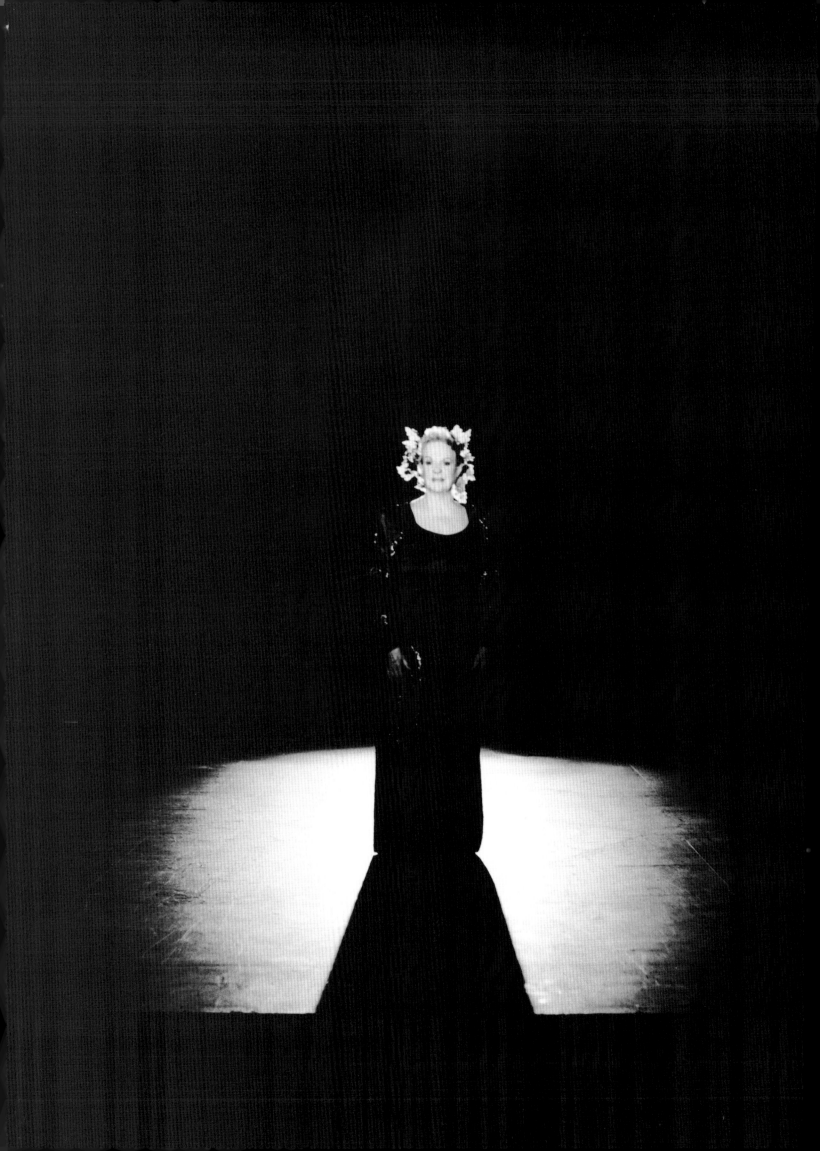

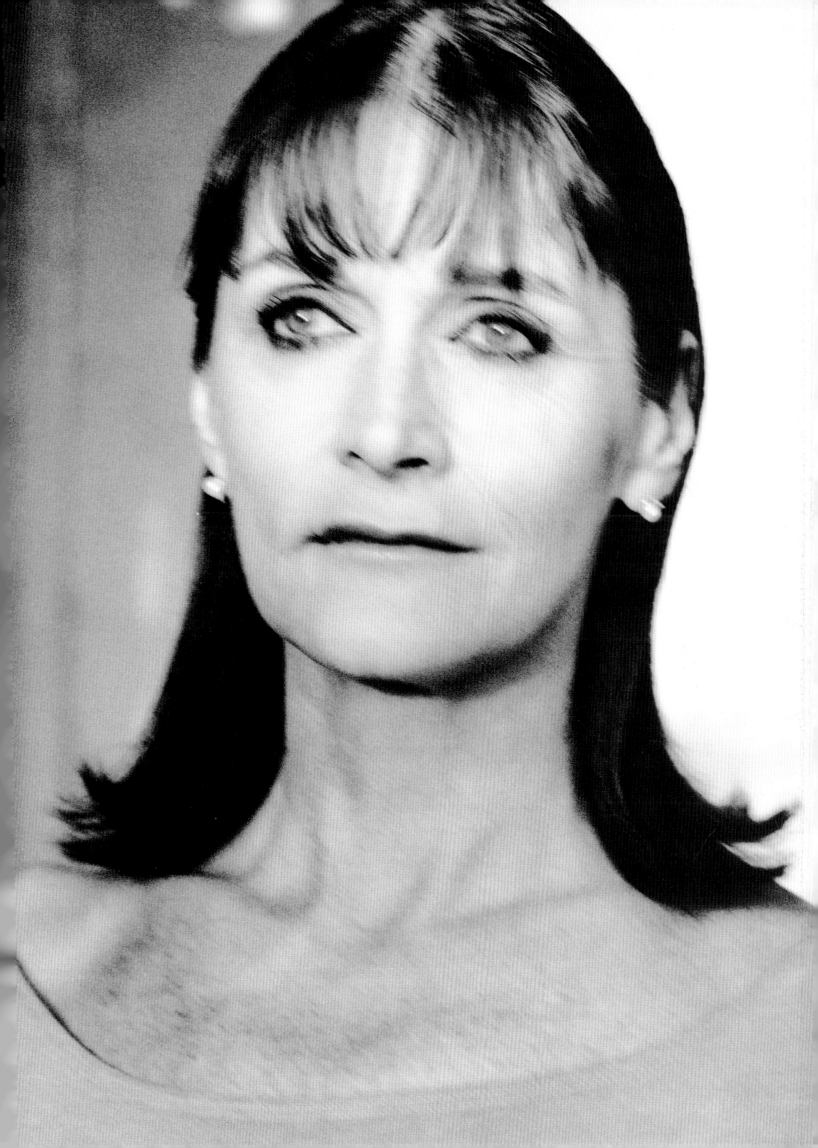

SARAH MCLACHLAN
singer/songwriter

previous spread

left

MAUREEN FORRESTER
contralto

right

MARGOT KIDDER
actor

inside gatefold

left to right

KATHY KREINER-PHILLIPS
Olympic skier
gold medallist

KATE PACE LINDSAY
World Championship skier
gold medallist

KERRIN LEE-GARTNER
Olympic skier
gold medallist

NANCY GREENE RAINE
Olympic skier
gold medallist
silver medallist

outside gatefold

NANCY GREENE RAINE

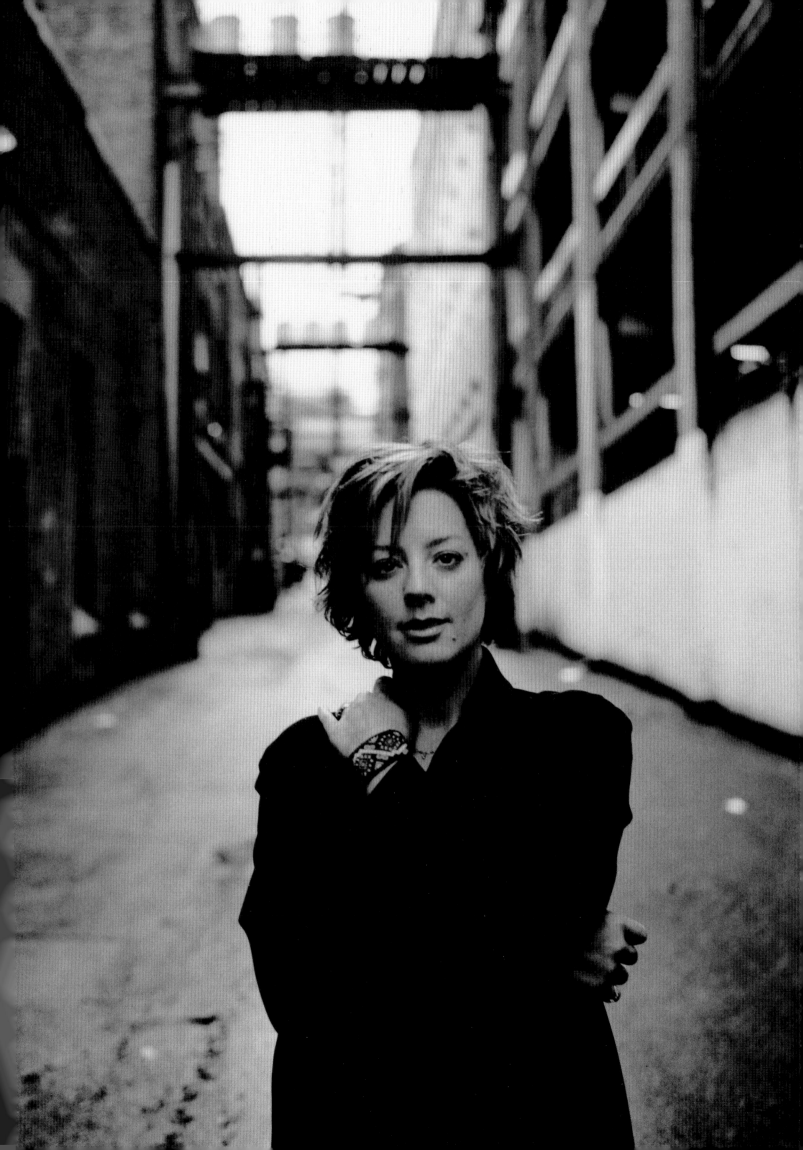

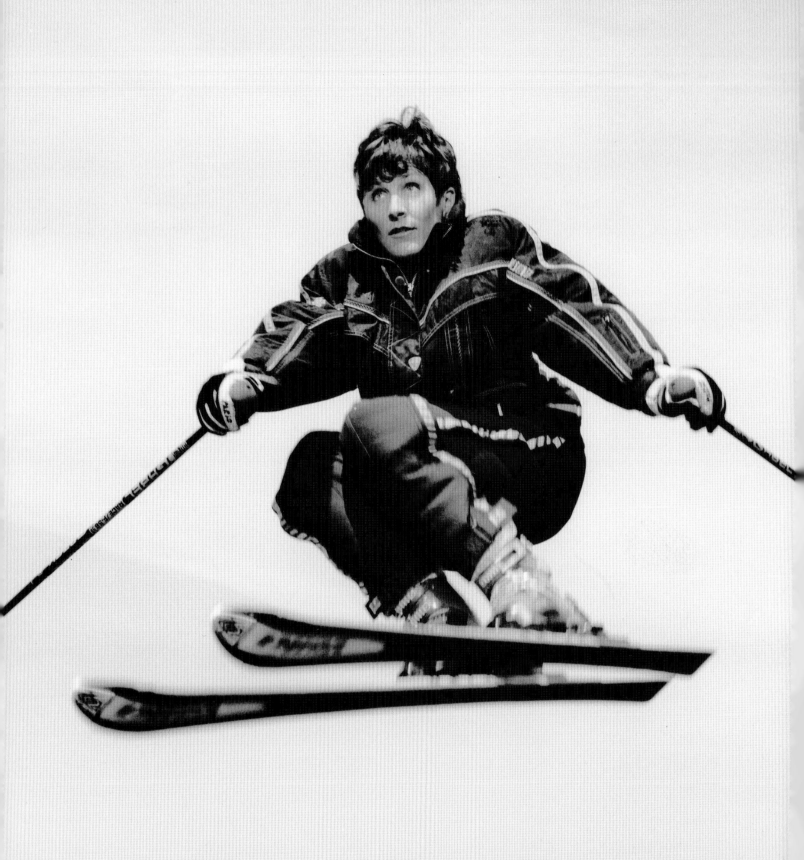

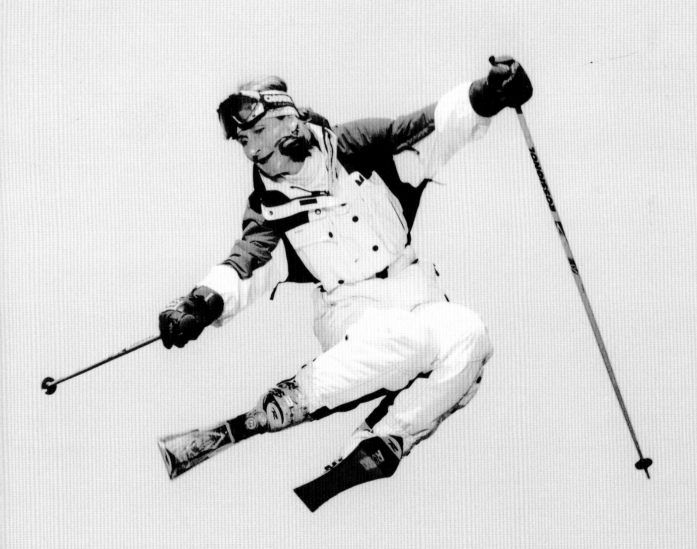

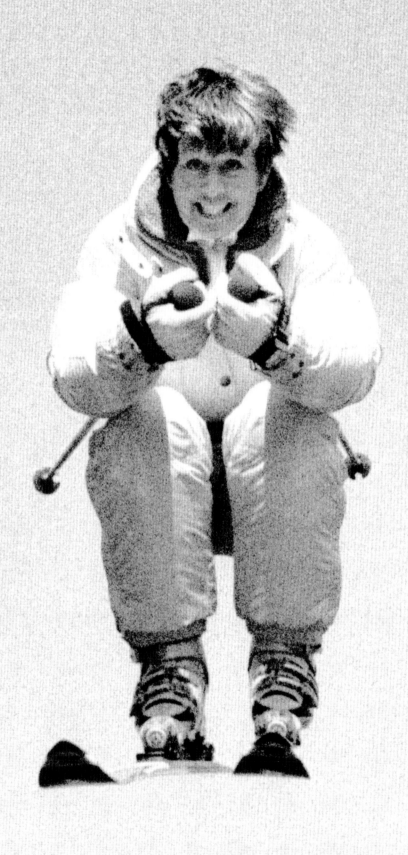

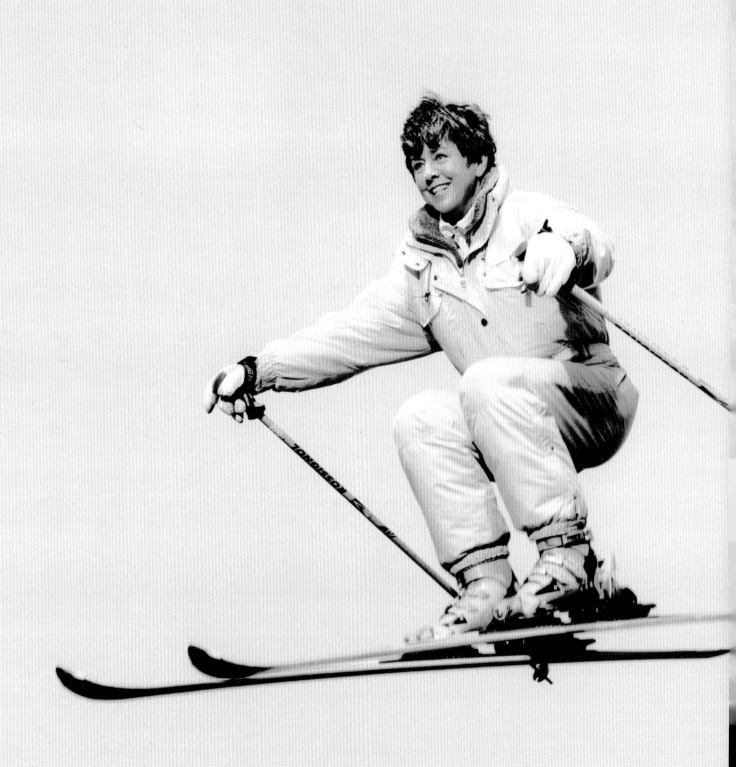

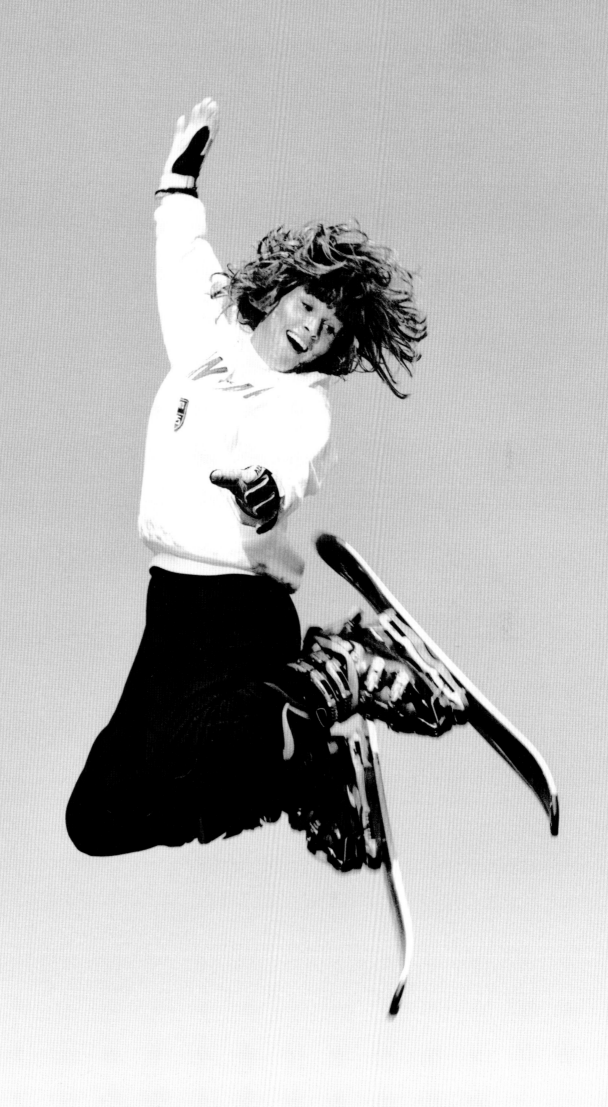

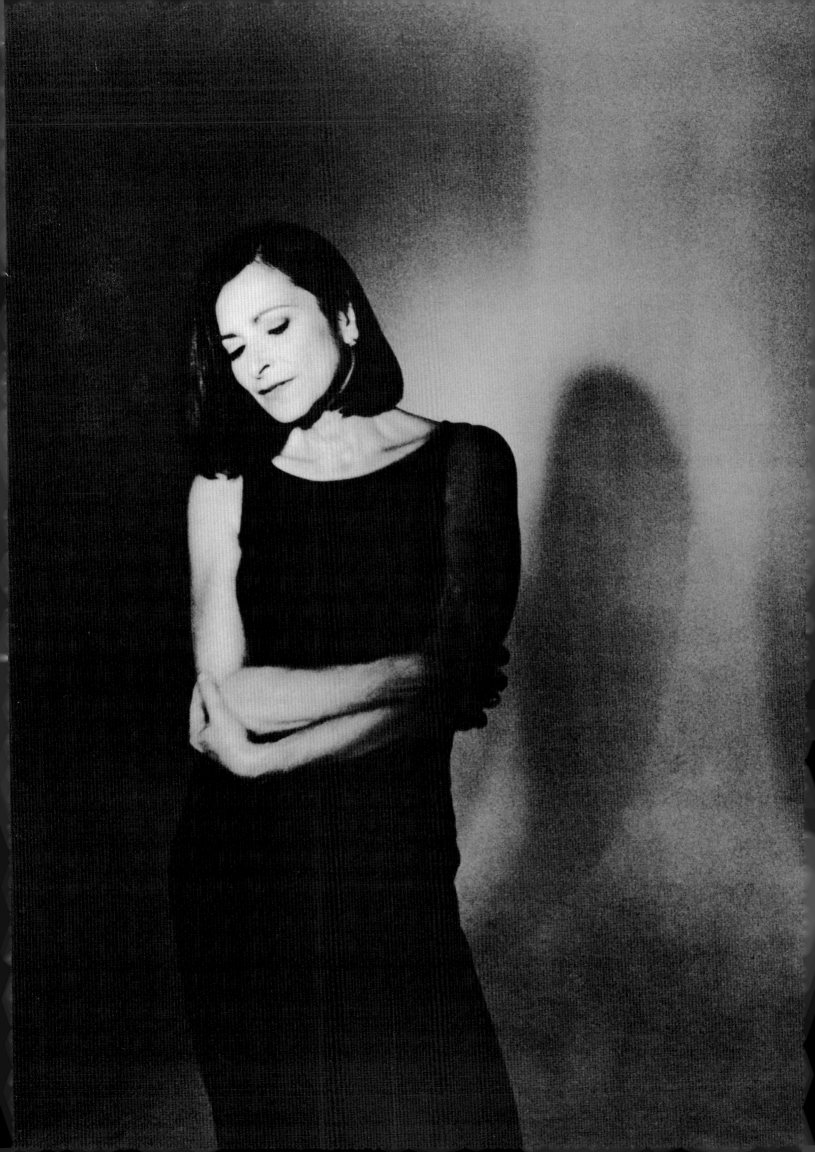

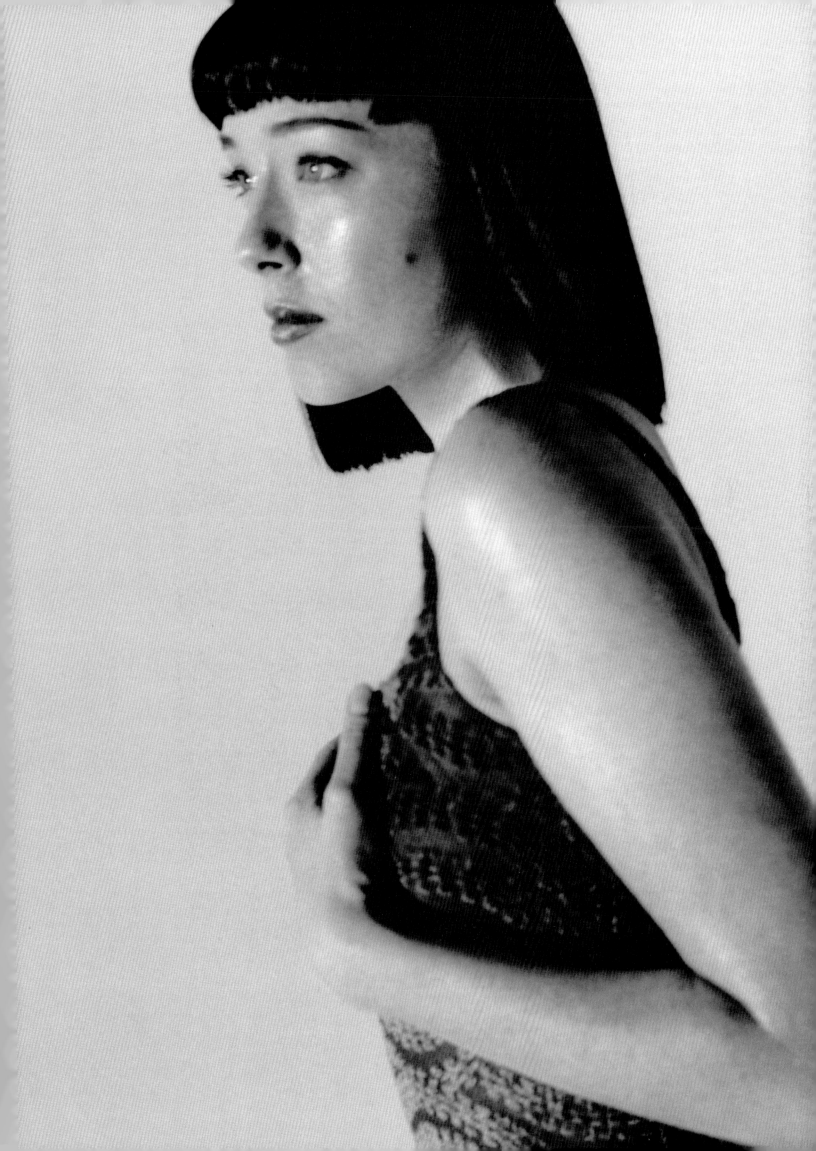

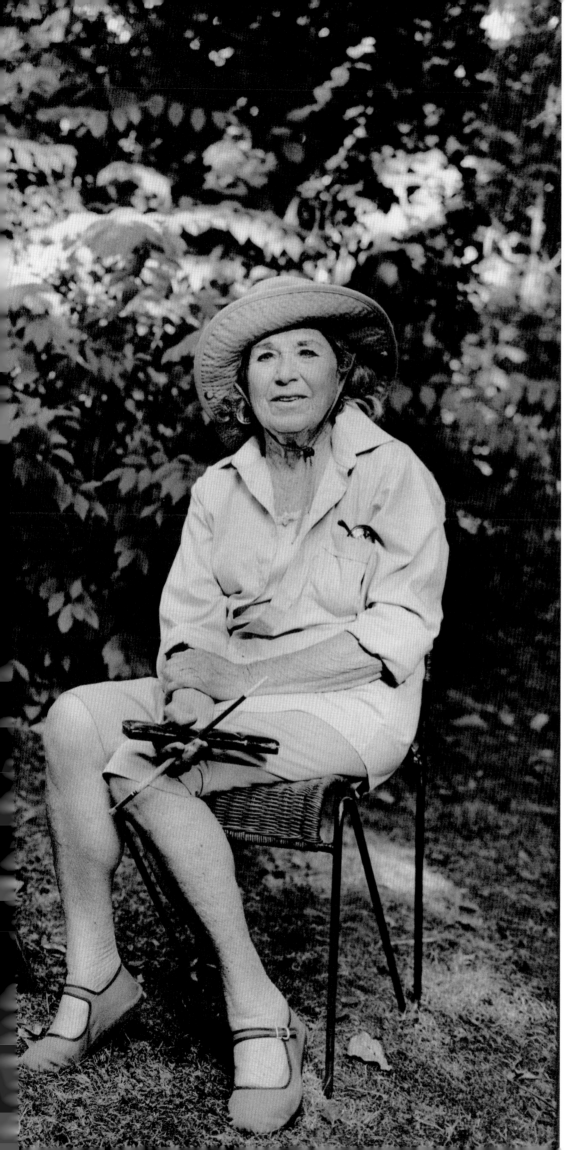

UNITY BAINBRIDGE, OBC
artist

previous spread

left
JEANNE BEKER
fashion journalist

right
MOLLY PARKER
actor

ALANIS MORISSETTE
musician

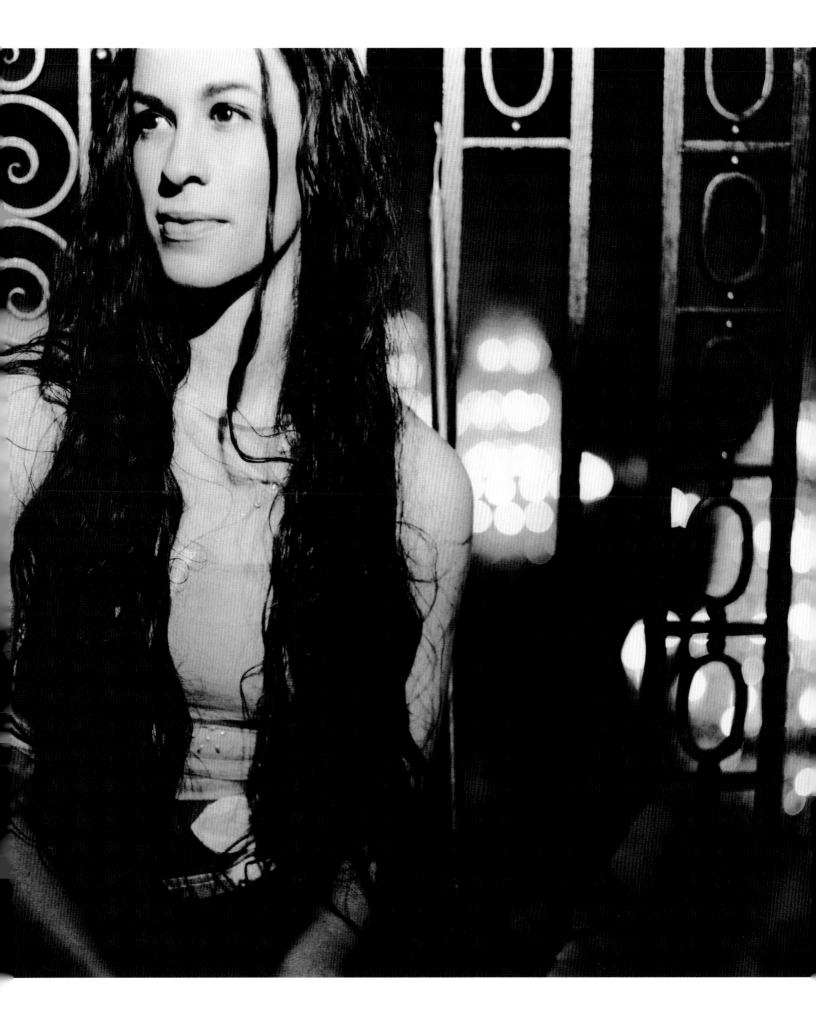

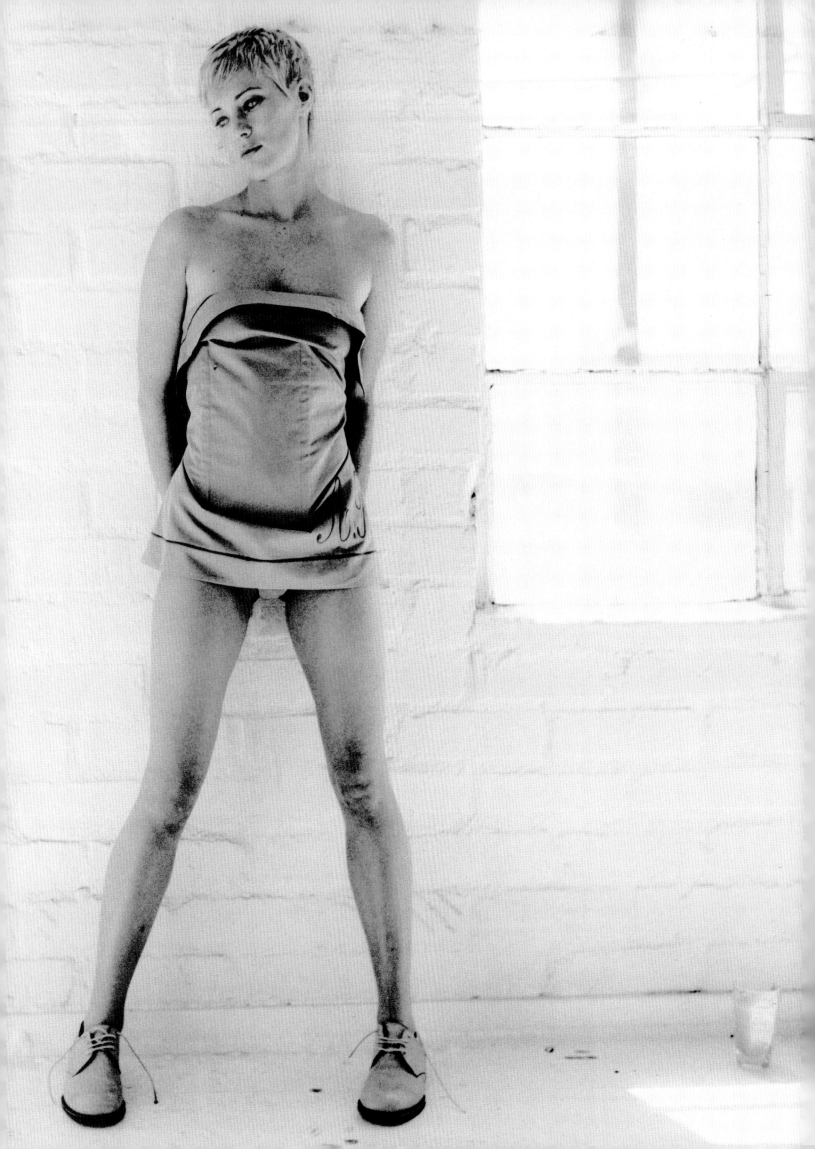

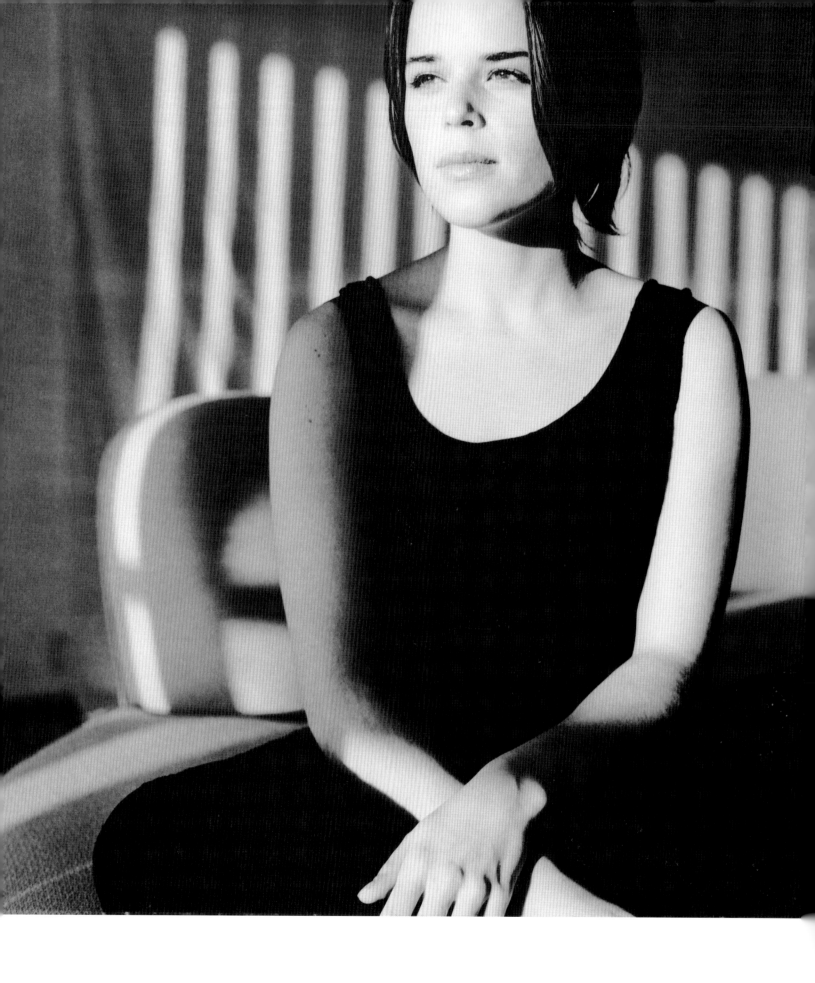

NEVE CAMPBELL
actor/producer

previous spread

ANGELA FEATHERSTONE
actor

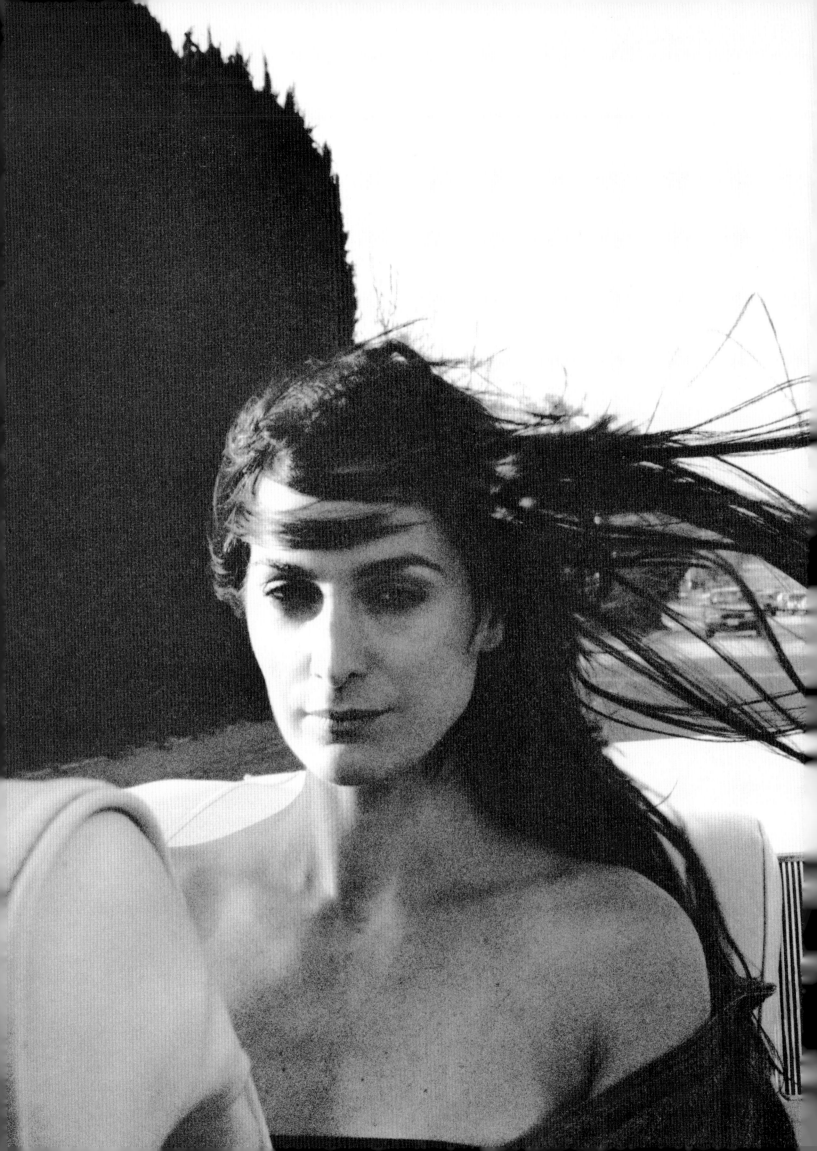

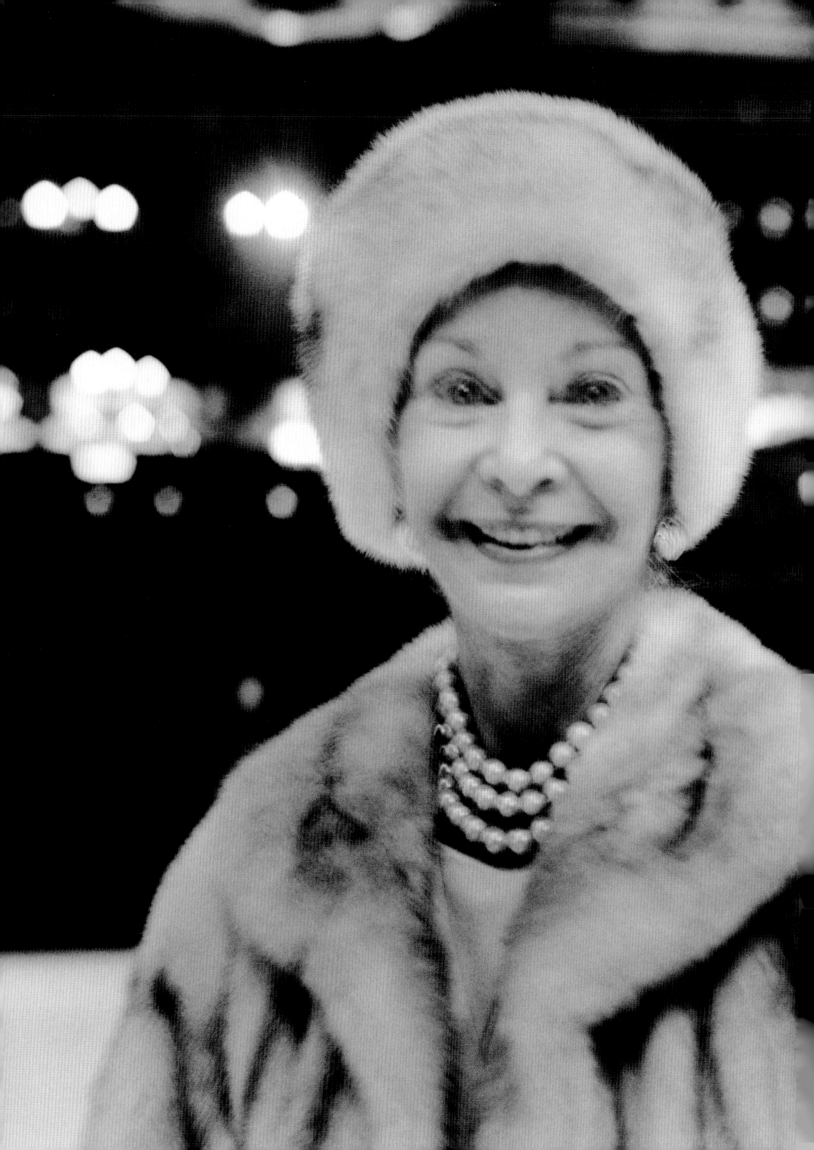

BARBARA ANN SCOTT-KING
Olympic figure skater
gold medallist

previous spread

CARRIE-ANNE MOSS
actor

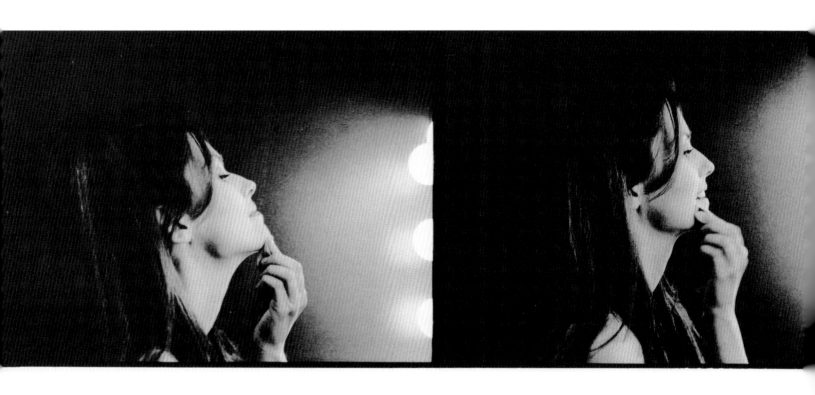

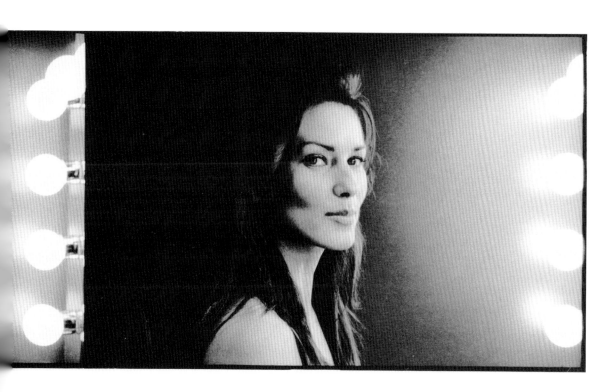

SHANIA TWAIN
singer/songwriter

DIANA KRALL
singer/pianist

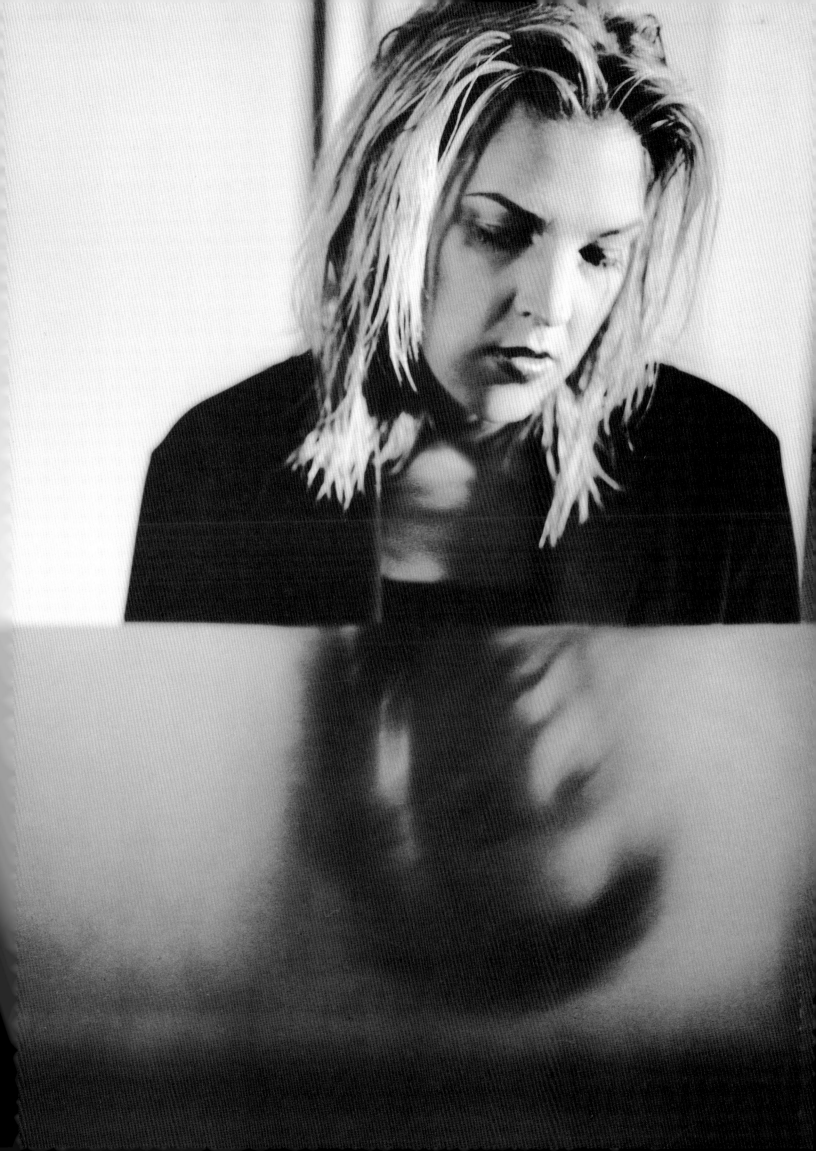

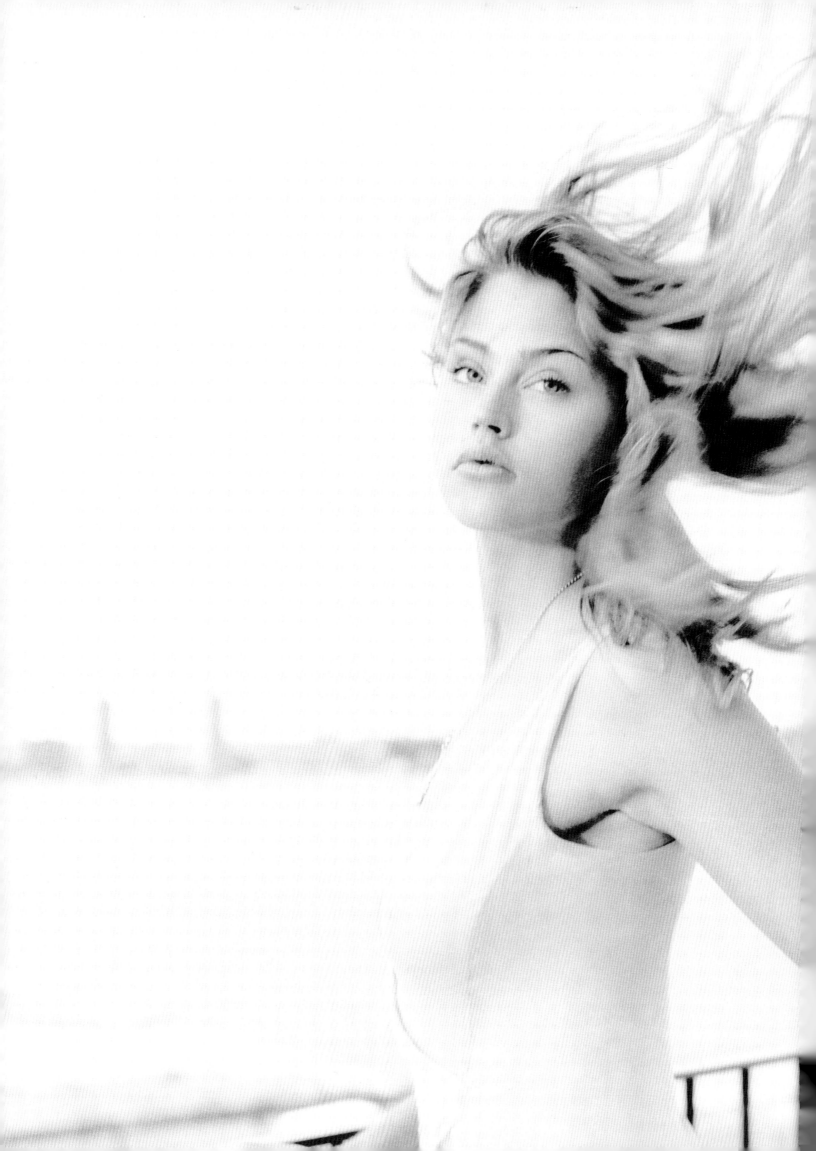

ESTELLA WARREN
model

JAN WONG
journalist

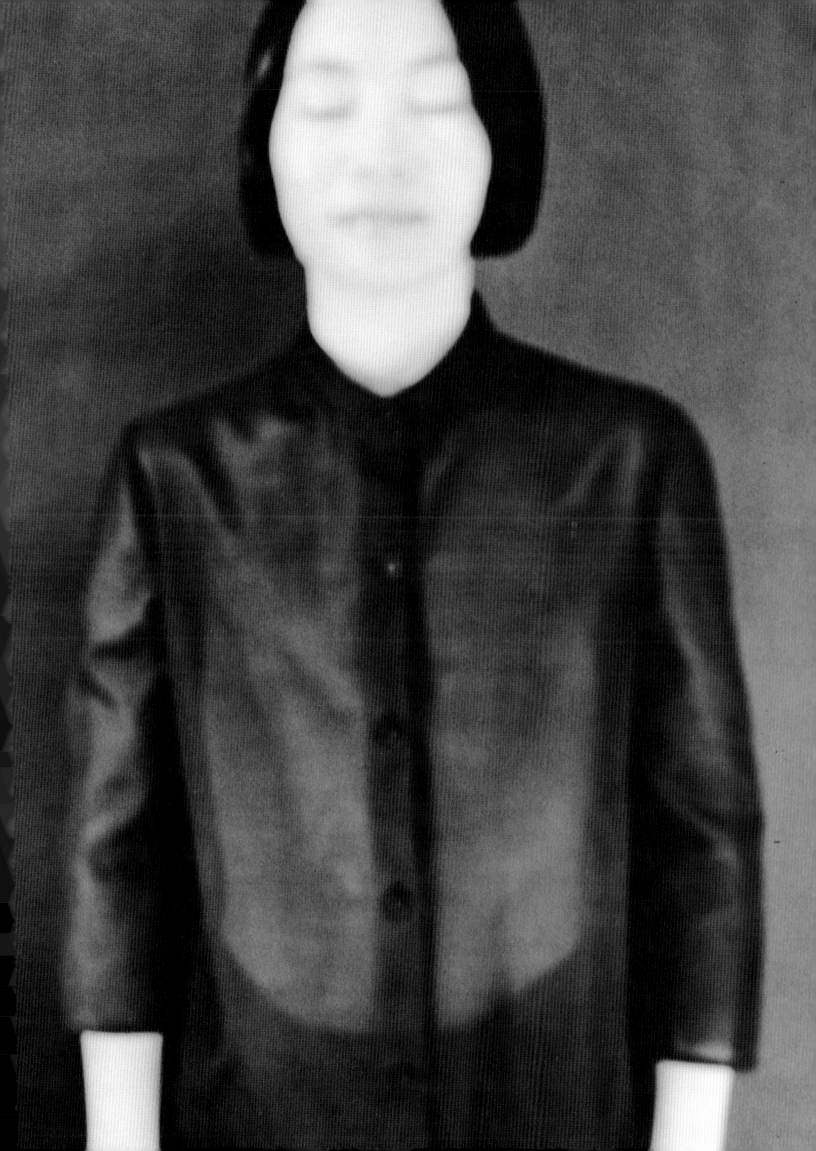

KIRSTEN OWEN
model

FRANCES HATHAWAY
makeup artist

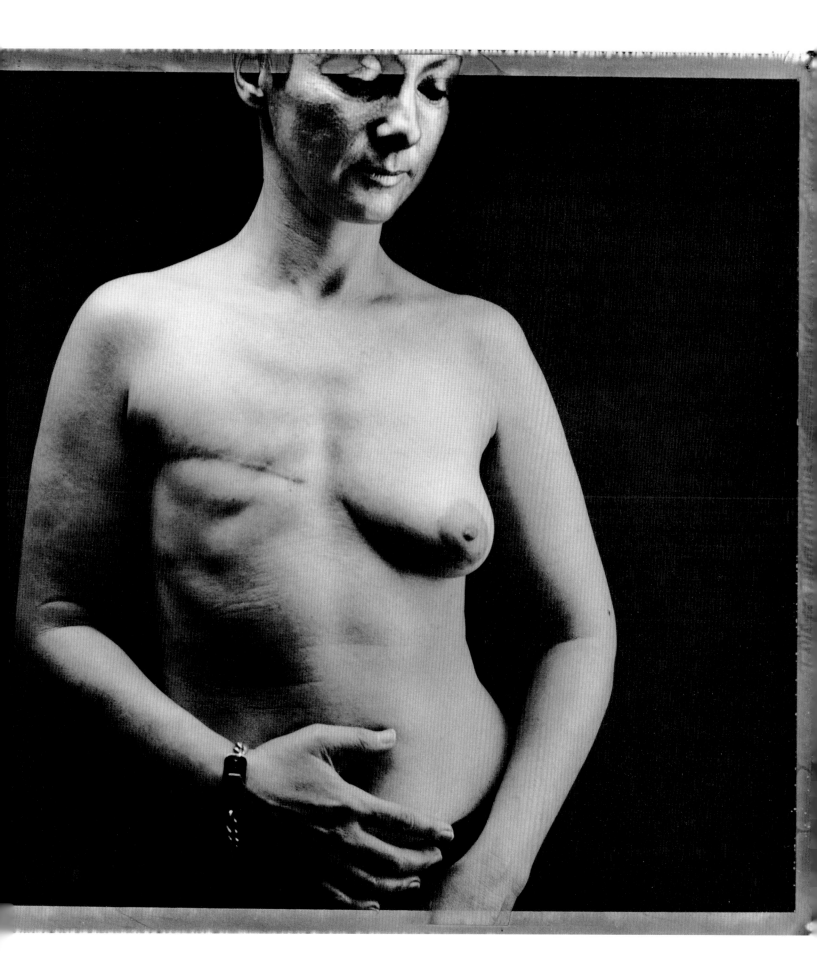

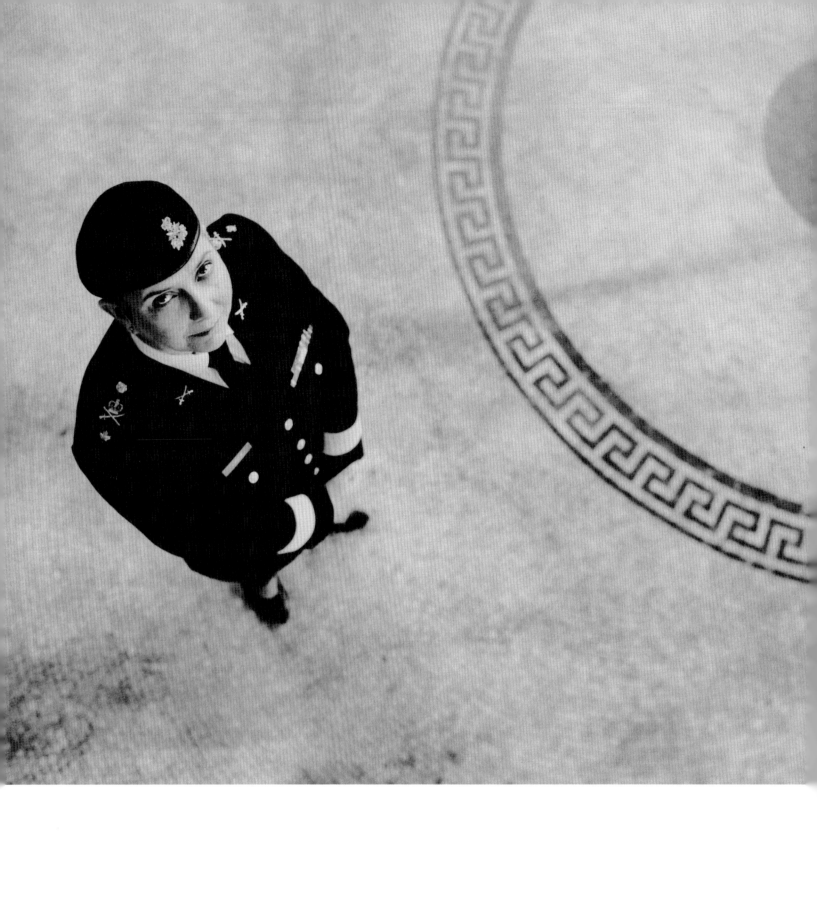

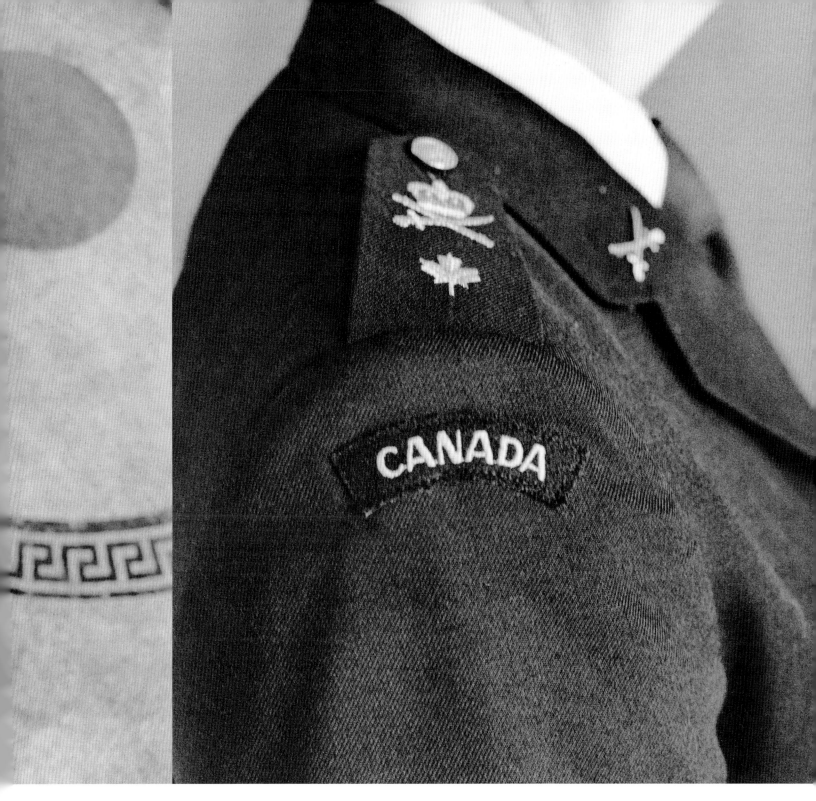

BRIGADIER GENERAL PATRICIA SAMSON
Canadian Forces provost marshal

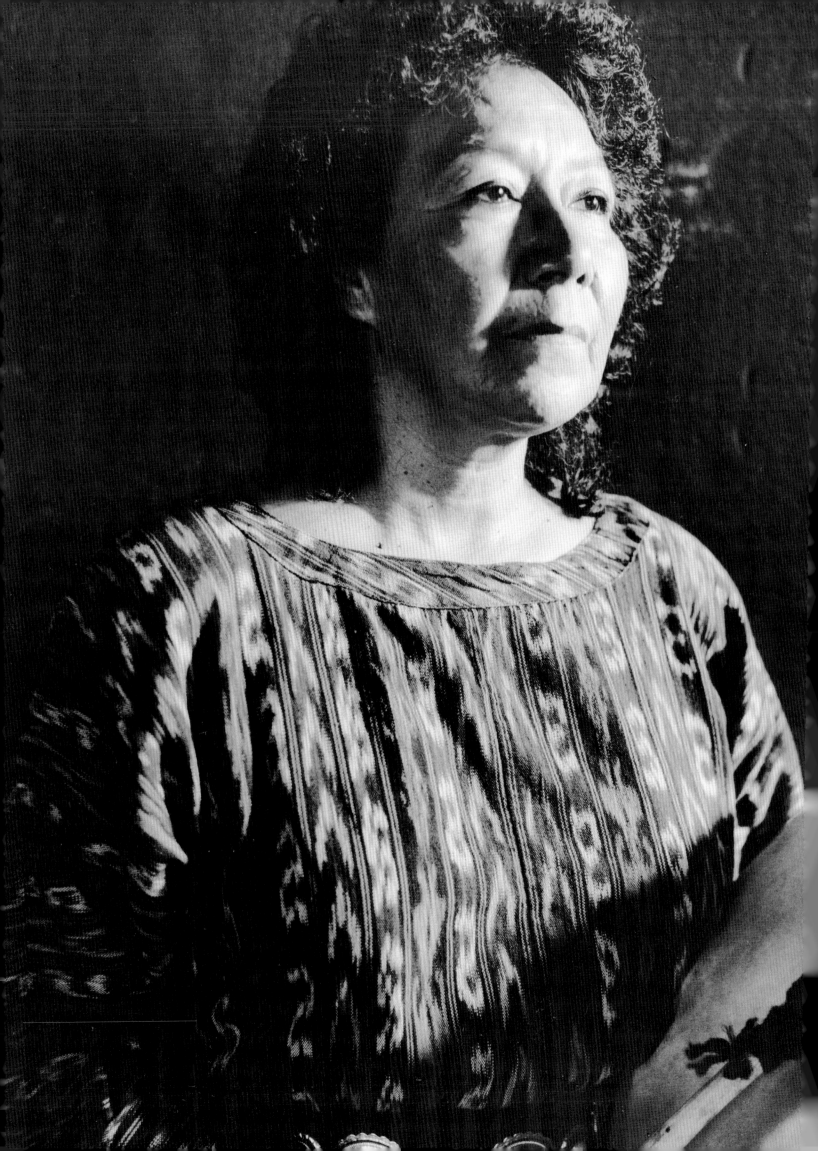

JACQUI LAVALLEY
cultural teacher

following page
DONNA

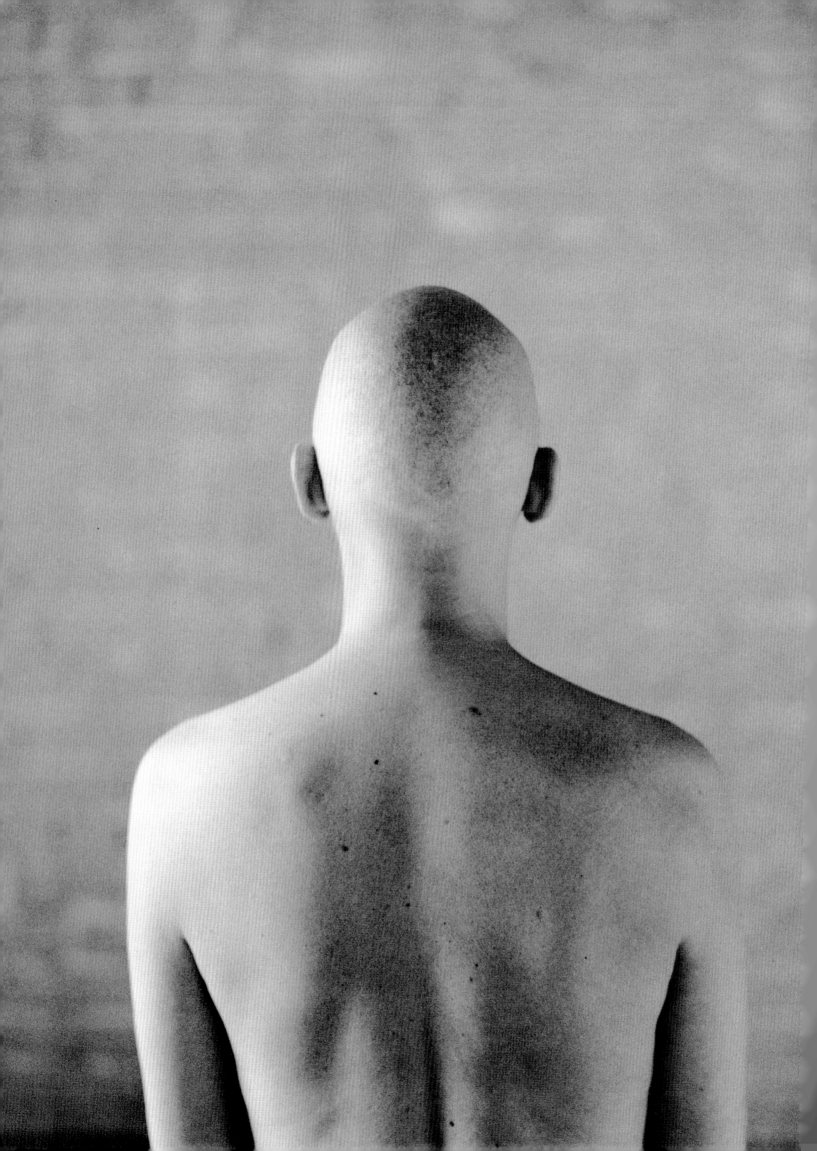

PHOTOGRAPHER'S ACKNOWLEDGMENTS

Thanks to the following people who donated their time and attention in different ways to make this book happen: Bruce Adams, Conrad Adams, Bruce Allen, Erik Asla, Lair Beattie, Howard Berman at Mercury Records in England, Randy Berswick, Paige Birnie, Kim Blake, Michael Boadi, Suzanne Boyd and everyone at *Flare*, Danny Clinch, Anton Corbijn, Perry Curtis, Karin Darnell, Jennifer Dynof, Holly Elkjer, Linda Evangelista, Mak Gilchrist, Mindy Gross, Sian Hall, David Hamilton, Guido Hoffmann, Barton Jahncke, Jane (my mum), Beth Katz, Alex Keeling, Nora Kryst, Helmut Lang, Hannah Lawrence, Rick Lecoat, Berndt Luchterhand, Kevin O'Neill, Paul Rae, Jo Raphael, Vicki Russell, Michael Schaeble, Miles Siggins, Brian Suckut, Jim Teat, Cecilie Thomsen and Linda Vermeulen.

Special thanks to David Fahey for his advice . . .

. . . and very special thanks to Herb Ritts for the generous use of his studio and staff when I shot in L.A., and to my pal David Jakle for tirelessly donating his time and talent to help me out in every way — and reminding me to take the lens cap off. Cheers!

For their kind and generous assistance, I would like to thank: Arts Umbrella/Vancouver, Robin Bernard of Tapestry/London, Carrie Bishop and the Four Seasons Hotel/Los Angeles, Canadian Opera Company/Toronto, Crosseyed Studios/New York, John Guillaumot and Le Royal Meridien King Edward/Toronto, Hershey Centre/Mississauga, Jenny, Shelley and Keith at Downtown Darkroom/London, Twon Klawer and Wendy Appleton of The Vancouver Board of Parks and Recreation, Katie Little, The Music Hall/Toronto, Ed Rak and Clinton Recording Studios/New York, Alistair Rose at The Pro Centre/London, Werner Schmalz of Kindermann for the Leica Lens, Seneca College, King Campus/King City, Kanwal Sharma/Apple Computers and all at Applemasters, Shin Sugino and his staff, Sundance Trampolines/ Vancouver, The Warehouse Studio/Vancouver, Jill Wurflinger, the Vancouver Rowing Club and Vitra/London for the great chair.

Finally, thanks to all the photo assistants, wardrobe and prop stylists, hair and makeup people, drivers, designers, agents and retailers whose contributions were invaluable: Ashley Anderson, Teddy Antolin, George Antonopoulos, Uzi Ashkenazi, Carol Beadle, Tom Bird, Greg Bitterman, Michael Bonneville, Alex Borovoy, Mark Botting, Catherine Buchner, Sarah Butler, Rudy Calvo, Sophie Carbonell, Luigi Carrubba, Anthony Chan, Reid Cohoon, Christy Coleman, Gina Crozier, Perry Danforth, Priscilla De Marchi, Dean Decent, Tracy Delaware, Jay Diola, Alex Dizon, Brian English, Debra Ferullo, Richard Fitoussi, Russ Flatt, Arlene Forester, Eric Forman, Jeff Francis, Renee Getsey, Gabriel Georgiou, Justin German, Stacy Lee Ghin, Jackie Gideon, Ilona Grace, Jonathan Griffith, Roslyn Griffith Hall, Pascale Grise, Andrew Haagen, Donna Hall, Jamie Hanson, Frances Hathaway, Marjut Hirvonen, Steven Hoeppner, Susan Houser, Tracy Juliver, Annelu Keggenhoff, Brad Laughton, Lorraine Leckie, Jennifer Li, Carol at Limber's Dancewear, Kathy MacKenzie, George Moreira, Pamela Neal, Chris Nefs, Brad Nelson, Simone Otis, Rebecca Palmer, Peno, Fritz Picault, Christos Prevezanos, Raphael, Steve Ratliff, Lisa Robbie, Stan Romero, Patrick Sauve, M. Maarten Sluyter, Zoe Taylor, Orna Tisser, Craig VandenBrul, Maria Verel, David Walsh, Tanya Watt, Mike Webb, Gucci Westman, Stephanie White, Stephen Wolter, Anna Woodrow, P'tricia Wyse, Ringo Yip, Lucienne Zammit, Marlene Zwart.

CREDITS

art director	Hans Dorsinville
project manager	Cheryl Smith
project coordinator	Michael Schaeble
copy editor	Debbie Madsen
research assistant	Elisabeth Bell

Photographs printed by Mike Spry at Downtown Darkroom
Photographs © Bryan Adams

Canadian Cataloguing in Publication Data

Adams, Bryan

Made in Canada

1. Women – Canada – Portraits. 2. Portrait photography – Canada I. Title.

TR681.W6A325 1999 779.24'92 C99-931094-1

Key Porter Books Limited

70 The Esplanade

Toronto, Ontario

Canada M5E 1R2

www.keyporter.com

Scanning and filmwork: Tom Childs / Quadratone Graphics Ltd.

Printed and bound in Canada

99 00 01 02 03 6 5 4 3 2